THE **ART** OF THE **HEADSHOT**

A Handbook for Photographers, Actors, Models and Self - Promoters

LANCE TILFORD

LIMELIGHT MEDIA
Saint Charles , MO

The Art of the Headshot
A Handbook for Photographers, Actors, Models and Self - Promoters
Lance Tilford | www.lancetilfordphotography.com

All photos © 2008 - 2011 Lance Tilford Photography
No portion of this book may be used, copied or reproduced without written consent of Lance Tilford or Limelight Media LLC.

Hair, Makeup & Styling by Tamara Tungate | www.tamaratungate.com
Book design by Maria Copello | www.mariacopello.com

© Copyright 2011 Lance Tilford
All rights reserved

ISBN: 978-0-9833326-0-2
First Edition

Warning: Real Live Talent Used In This Book!

A note to agents, casting directors, big-time producers, producers with indy cred, and corporations with deep pockets needing to hire talent for industrials: the actors and models whose headshots are featured in this book are real, live working actors and models. If you see a face in this book who is perfect for your next project, you can email the author, who will email their agent, who will "get with you."

Acknowledgements

I wouldn't be a headshot photographer today if it weren't for my wife Tamara, who forced me at gunpoint (well, pregnancy point) to leave a perfectly good paying job and move halfway across the country to start a photography studio specializing in on-camera talent, and making me think it was all my idea. She is also an on-camera talent. Hey, this turned out awfully convenient for her....

I do offer sincere gratitude and thanks to the talent and modeling agencies, particularly in the St. Louis area, which we have worked with. Limelight Studio wouldn't exist without their support and encouragement over the years.

All images © 2008 – 2011 Lance Tilford Photography

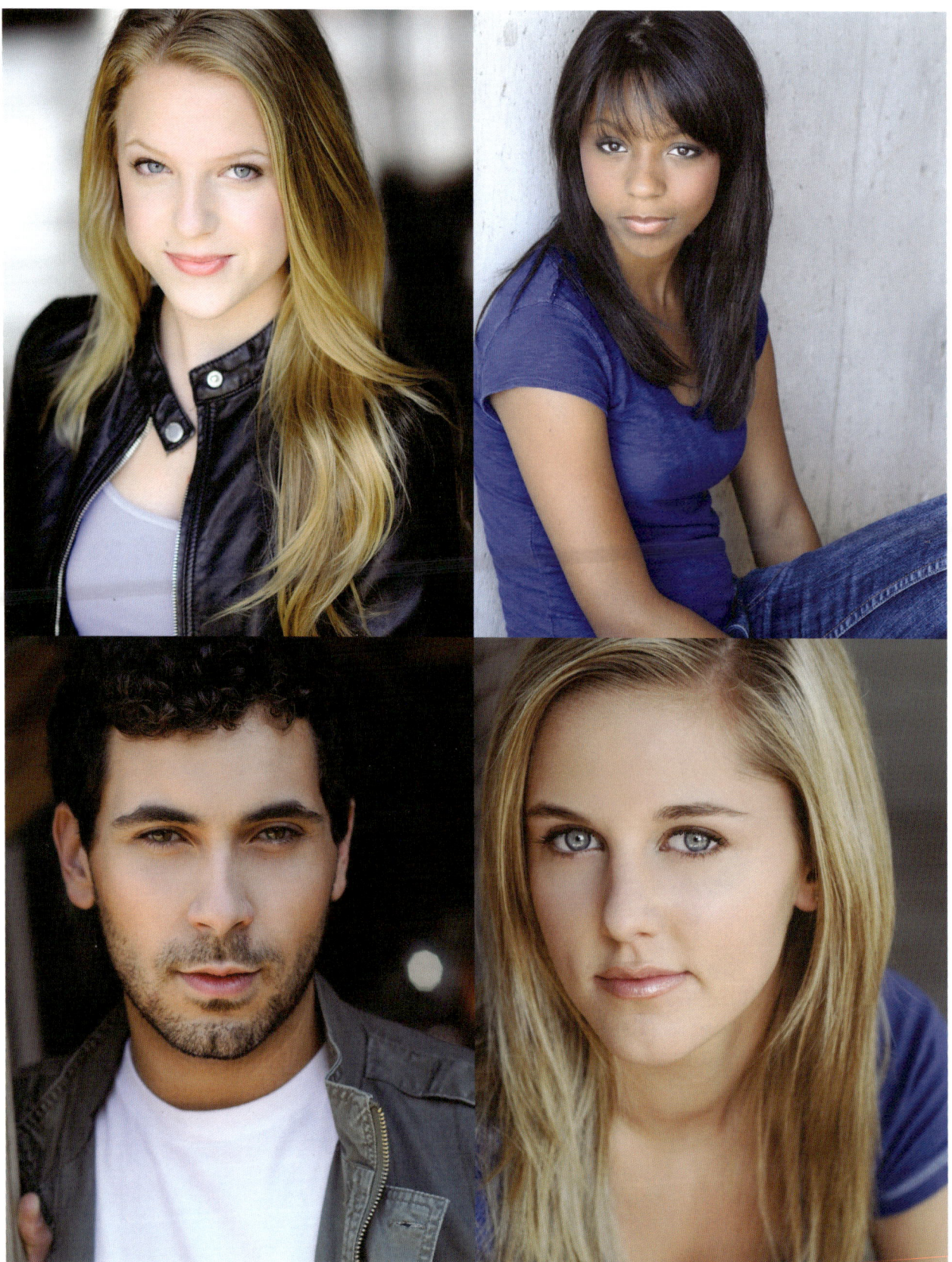

TABLE OF **CONTENTS**

14 **INTRODUCTION: EVERYONE NEEDS A HEADSHOT!**

16 **A NOTE FOR THE TALENT**

17 **A NOTE FOR PHOTOGRAPHERS**

18 **THE COLLABORATION**

20 **GOOD HEADSHOT PHOTOGRAPHER SKILLS**

21 **GOOD HEADSHOT TALENT SKILLS**

22 **JUST GETTING STARTED?**
 Beginning Photographers..22
 Beginning Talent..22
 When Do You Need Professional Images?..23
 Free Shoots, TFPs, Posers and Scams..24

26 **WHAT IS A HEADSHOT?**
 Color or Black-and-White?..27
 How Do You Know If A Headshot Is Working For You?...................................28

30 **ARE YOUR HEADSHOTS WORKING?**
 Headshot Killers..30
 Headshot Savers..31

33 **TYPES OF HEADSHOTS & PROMOTIONAL IMAGES**
 Commercial Headshot...34
 Theatrical/Film/Television Headshot..36

Commercial/Theatrical Juxtaposition. ..38

Comparatives: Same Girl, 3 Different Headshot Types. ...40

Comparatives: Same Guy, Different Looks. ..41

Corporate/Professional/Industrial Headshot. ..42

Author/spokesperson Headshot. ..43

Pageant Headshot. ..44

Body Shots. ..46

Body/Fitness. ...47

Lifestyle Shots. ...48

Performer (Theatre/Stage/Musician) Headshots. ...50

Model Headshot. ..52

54 MAKING A FASHION STATEMENT

58 CHILDREN

61 LIFESPAN OF A HEADSHOT

62 THE COST OF HEADSHOTS AND PORTFOLIOS

Costs. ..62

Photography & Styling. ...63

Processing & Retouching. ...63

Prints & Media. ...63

65 FINDING A PHOTOGRAPHER

Problem Photographers ..66

68 FINDING TALENT

Talent Challenges. ...68

71 PREPPING FOR A SHOOT — PHOTOGRAPHER AND TALENT

The Consult. ...71

Determining Optical Range: Aging Up and Aging Down. ..72

Digital Or Film?. ..73

The Candid. ..75

76 AT PEACE WITH WARDROBE

The Personal Shopper. ...76

Wardrobe Costs and Bartering. ..77

Wardrobe Suggestions. ..77

80 MAKEUP & STYLING

I Can Do My Own Damn Makeup. ...81

Hair. ...82

Makeup. ...83

General Makeup Tips & Suggestions. ...84

Skin Care. ..85

86 ON-SET STYLING

Glasses. ...86

The Teeth, the Whole Teeth, and Nothing But the Teeth. ..86

88 PERSONAL PREPARATION

89 THE SHOOT

Locations and Backgrounds. ..89

Environmental Backgrounds. ..89

In-Studio Backgrounds. ..90

Cyc Wall/White Seamless. ..90

Light. ..91

92 GETTING THE "ENERGY"

94 FRAMING THE SHOT
Session Lengths. ..96

98 DIRECTING FOR EXPRESSION

102 BODY LANGUAGE

104 REVIEWING THE SHOOT

105 WORKING WITH AGENCIES
Agency Packages And Schools. ..108

Working With Independent Talent. ..109

112 CHOOSING "THE SHOT"

113 SHOOT EDITS & SHOT SELECTION
Proof Formats and Delivery. .. 114

Conflicting Opinions. ... 115

Talent Self-Assessment. .. 116

Reshoot Policies. .. 117

118 RETOUCHING
Effects and Backgrounds. ... 119

Skin Tones. .. 119
Skin Problems. .. 119

Braces. ..120

Missing Teeth. ...120

"Life Retouching". ...120
Overheard At The Retoucher's Desk. ...121

The Ten Most Annoying Things To Retouch. ..122

Review the Retouching...123

The Subconscious Flaw...123

124 COLOR CORRECTION

Monitor Calibration..124

125 DELIVERING HEADSHOTS

126 REPRODUCTIONS, COMP CARDS & MEDIA

Headshot Borders..127

Creating a Quick Home-Printed Headshot..128

Creating a Simple Headshot Template in Adobe Lightroom®..129

Landscape vs. Portrait Modes...130

The Care and Feeding of Your Headshots..131

Digital Portfolios...131

I Want My DVD!..131

Print Procrastinators...132

Attaching the Resume..132

134 COMP CARDS

135 BUSINESS CARDS AND OTHER PROMOTIONAL MEDIA

136 DIGITAL VIDEO HEADSHOTS, BIOS, SLATES, & AUDITIONS

The Video Headshot/Bio/Slate..136

The Video Audition...136

138 THE HEADSHOT MARKET FOR PHOTOGRAPHERS

140 MARKETING YOUR HEADSHOT – FOR TALENT

141 COPYRIGHT & IMAGE PROTECTION
Who owns the images? ... 142

Usage. .. 142

Metadata and Image Tracking... 143

145 THE TALENT/PHOTOGRAPHER RELATIONSHIP

146 GLOSSARY

148 FOR MORE INFORMATION

149 ABOUT THE AUTHOR

INTRODUCTION: EVERYONE NEEDS A HEADSHOT!

Welcome to the Headshot Nation! It's the age of social networking, where image is everything and the little avatar icon reigns supreme as the "first impression ambassador" on the world's cyber highways. Is your image a true reflection of you or are you displaying a false front?

It's also the age where these two notions apply:

- **Everyone's a photographer:** the advent of cheap and easy digital photo capture devices (your cell phone, for example) has turned even luddites into capable picture takers, and it's turned former photo hobbyists into rabid marketers posting their images every 5 minutes to the many photo-sharing sites, and all of this is giving the average long-time portrait photographer a run for their money

- **Everyone's an actor, spokesperson or model:** whether or not you are on stage, in film or television, you have a face and you probably have a job and you are seeking opportunities for promotion and advancement, in the workplace and in the social stratosphere—and your picture usually has to make the first impression for you

Andy Warhol's old quip about everyone being famous for five minutes has turned out to be wonderfully and tragically true; but even he did not foresee that those 5 minutes could, via today's technology, be replayed and reviewed over and over and over again. People are definitely putting their image out there, but the vast majority of those images are ghastly, cheap, and technically atrocious. Look at the pictures of supposedly professional people all around any town; even those politicians, real estate agents and lawyers whose pictures litter billboards, flyers and TV promos have horrid, poorly lit, unstyled images. Does it instill confidence that your first impression of these professionals is tainted by their cheapness and inattention to the display of their own persona?

And then there are those who choose not to show a picture of themselves at all. Hiding behind creative avatars, pictures of their pet or favorite image icons might be OK for some, but anyone trawling the internet with a Facebook, LinkedIn account, personal or professional blog or personal webpage is most certainly going to be best served with a current, realistic image of themselves. Having a few different images in one's arsenal—something professional for those online job searches, something casual for that dating service—is a really smart idea. The more seriously you take yourself and the more professionalism or confidence you need to project should mean that you're willing to make the investment in professionally done, professionally styled headshots.

So, we're a Headshot Nation—but if the average headshot on display were edible, it wouldn't even qualify as junk food. Those sexy camera-phone images project desperation; those little strip-mall portrait studio shots scream "cheap!" Those overly styled, glammed-up shots may be fun, but you might as well use clown makeup. A good photographer and a good stylist know how to create a true headshot that projects your honest look, your style, and your personality—on a really good day.

I'm a photographer who specializes in shooting headshots, so I of course believe that everyone should be required by law to have a good current headshot, updated at least once every two years. And you should be able to use that headshot on your state ID, driver's license, passport, and your own personalized cereal box. Just sayin'.

When you get a really good headshot, it can open doors for you well in advance of your physical presence. This is true for everyone, whether you're a professional networking online, or whether you're a struggling actor looking for that big break. Being an instant visual projection of your persona, the headshot is in many ways the single best investment you might make in yourself.

This book is primarily geared toward professional or semiprofessional photographers and for talent who are currently working or are seeking to work on camera (as actors, models, spokespersons). However, anyone whose stock-in-trade is their image (or creating images) would greatly benefit from fully understanding the process of how one's headshot, promotional or portfolio images are created from first step to the final product, and in seeing the types of images that could benefit them the most. A headshot is not a portrait. Headshots and portfolio images are *product* shots—but the product is a *person*.

For the purposes of simplicity, throughout this handbook I'll generally refer to "talent" as whoever is in front of the camera (so if you're a very untalented politician or corporate professional in the public eye, this means you too). Prim grammarians and uptight editors beware, I switch willy-nilly between second person subjects—"you" will sometimes refer to talent and sometimes to the photographer, depending on what issue I'm addressing. I trust "you" will know who "you" are. I will also repeat certain important tidbits of information or items I strongly suggest, because I assume in the "short attention span" world that many readers will be skipping around a bit.

Though the book's title begins with "The Art of…", this book is very much about the "business of" creating the "art." It's not about being artistic (photographers) and talented (actors etc); it's about how you create an image intended to market a talent or someone whose self-promotion depends on their image.

In the Headshot Nation, that includes everyone.

A NOTE FOR THE TALENT

Are you pursuing work as an actor, model, or spokesperson? Are you frequently in the public eye and need to market your image? For on-camera talent, your image is the product you're selling, and capturing and distributing that image is your most vital sales tool. Professional casting directors and agencies (or clients you want to impress) will be viewing your pictures, so you should be giving them professionally shot and styled images.

Some actors and models outside of major markets may think they don't need professionally crafted sales tools; but no matter where you are, if you are seeking a role in anything but community theatre and put your image on the internet, via an actor's service listing, casting sites, your agency's website or your own promotional website, you are competing with actors across the continent. A part-time beginning talent in a small town should have as sharp a headshot as a full-time talent in New York or Los Angeles. If you are a model, professionally created portfolio images are what you need to market yourself. If you are a spokesperson or business professional, guess what? ***Only professionally created images are going to project your professionalism***; not your local one-hour portrait studio. If you want the market to consider you a professional, you had better present yourself as such.

As you will read throughout this book, you will need to make a concerted effort to achieve a great headshot or images; it's a lot more work than just standing in front of the camera and smiling. This is your investment in your most important business asset: yourself!

A NOTE FOR PHOTOGRAPHERS

If you are a professional or semiprofessional photographer who wants to shoot actor headshots, model portfolios and promotional images for on-camera talent or other professionals, then you need to know the very different types of planning, styling and coordination involved in working with professional and semi-professional talent. This handbook does not dwell on technical specifications in exposure and lighting or camera settings; there are plenty of great resources and camera workshops to spend your time with for technical expertise. I am assuming you know your camera and are already a skilled practitioner of digital photography. If not, then that's your first step. A special set of skills beyond photography is needed to get the best images your client can use to market themselves. It also will involve interacting with professional stylists and talent agencies. If you are a traditional portrait or wedding photographer who shoots beautiful images, or if you are an outstanding photographer whose work is creative and edgy, then you will probably need to exercise a very different set of skills to capture what on-camera talent clients need for their use. If you have never worked with a talent agency, casting agencies, or haven't had film/theatrical or entertainment marketing experience, then you have a learning curve to jump into. However, the rewards of shooting for on-camera talent are certainly worth it. Think about it; this is one area of photography that the client *must* have. They will rely on you for a certain level of expertise.

I strongly recommend that photographers who have had no previous theatrical, modeling or on-camera experience themselves take some commercial acting and/or directing classes. To photograph talent for a variety of promotional purposes, you need to know how to direct the talent and give them motivation, not just make them look good. It isn't about making them look all "Hollywood" and getting them to smile; it's about getting expressions that sell them, their personality, their potential characterizations, and their range. Getting a sense of what it feels like for them to "perform" can be helpful in giving directions on your own set.

Your goal is nothing less than taking a total stranger and capturing elements of their personality, range of expression, and style that will maximize their market potential and give you a strong portfolio of your own marketable images.

THE COLLABORATION

This handbook is written for both photographers and talent—it is not a technical manual on photography, nor is it a guide to acting, modeling or auditioning. It's about the preparation, process and collaboration that must be achieved in order to get "the shot" that best captures and markets the talent—that's why I've taken the unusual step of writing this book for both, because without understanding each other's part, getting the perfect headshot is difficult. Getting marketable shots is a professional endeavor on both sides of the camera; photographers would do well to know what it's like in the talent's shoes, and talent should understand the photographic process in order to manage the care and feeding of their own image.

When starting Limelight Studio, my partner and I each brought some unique collaborative skills to our approach in shooting actors and models. As the photographer, I had theatre, acting and directing experience. I attended film school in Chicago, and I had some film/video and directing experience. I had produced and hosted a cable television show working with local talent. I'd spent years in marketing in the publishing industry, which included working with book cover design—photographs and illustrations—that had to sell a story or an idea. The ability and confidence to direct an actor or model was key.

My partner had been an actress and model for many years, in theatre, commercials, industrials and major motion pictures, on large and small print ads. She'd worked with several agencies around the country, shot with countless photographers, and knew what images had worked for her over the years. When she took her own well-honed makeup and styling skills and became a professional makeup artist, she was not only able to assess someone's natural beauty and bring out their best look, she was able to make the little tweaks in makeup, hair and styling that emphasized different aspects of the actor/model's "look".

I'm not suggesting that you need to have years of experience as a director, or actor, or stylist. But a photographer of headshots and images that sell personality and expression should have some directing skills. It's highly recommended that you take a good commercial acting course and learn the skills and motivations actors are trained to work with, so you can speak on that level when you're shooting with them. Whether acting or modeling on-camera, there are unique skills the talent needs to possess and project, and the photographer needs to know what they are and how to direct for them.

For shooting portfolio images on print and lifestyle models, you need to study catalogs, ad campaigns and magazines for ideas. Identify the major companies in your region that hire on-camera talent for catalog and advertising purposes and be familiar with their campaigns

and the images they use. This is easy research to do on the internet. If you are attempting to shoot or model in the world of high fashion, please read the "Making a Fashion Statement" chapter later in this book.

Actors likewise need to study the types of images they need; can you achieve the kinds of expressions and body positioning those actors and models have displayed? It may sound silly, but a little practice in the mirror is always a good idea. Look at the headshots in agency directories in top-market cities such as New York City and Los Angeles.

GOOD HEADSHOT PHOTOGRAPHER SKILLS

These skills set the headshot photographer apart from the portrait or commercial photographer (and I am assuming you have already mastered the basics of photography):

- Acting/directing experience (film, video and/or theatre); being as much a good director as a good photographer is key

- Marketing experience (knowing how to position image and product for specific markets; talent is a product)

- People skills and ego management (the ability to connect with talent, put them at ease, initiate engaging conversation on a topic that interests them, and direct them as if they are performing)

- An eye for good styling (knowing the line between what's natural and what's too much in terms of makeup and wardrobe) and an ability to work with experienced stylists and makeup artists

- Use of depth-of-field to put the talent in clear sharp focus (and blow out/blur the background)

- The ability to capture a "caught in the moment," spontaneous shot

- An ability to gauge the subtle differences between types of "looks"—film, theatre, commercial, professional

- The ability to leave your ego out of it

GOOD HEADSHOT TALENT SKILLS

Skills an actor or model should be able to convey during a professional photo shoot:

- A great, natural smile (still nature's most inviting, universal expression)
- Ability to convey a variety of natural, believable expression (this can instill confidence in whoever is viewing your picture—believable expressions show that you are engaged, listening, that you can respond)
- Willingness to listen to and take direction
- Energy control—the ability to project and tone down energy and expression (how "loud" or "soft" your expression is has a lot to do with its sincerity)
- Sense of your "type" and how to project that with your own personality
- Confident eye contact (eye contact is the communication world's great equalizer)
- Preparedness in wardrobe and appearance
- The ability to put your ego in check

JUST GETTING STARTED?

BEGINNING PHOTOGRAPHERS

If you're a photographer just getting started and want to learn how to do headshots, of course you need willing talent and experience. An established professional headshot photographer in your city or region isn't likely to train you to be her competition. What can you do? First, consider the types of headshots you might likely be most comfortable working with. If you have a great deal of experience in the corporate sector or marketing, professional headshots could well become your strength. If you have theatre or film or acting experience, talent headshots could be where it's at. Study headshots on talent agency websites, corporate sites (and in this book of course) and practice on willing targets from local high school and community theatre programs. Ask professional stylists and makeup artists to do test shoots with you; they're a great source of experience and information to learn from because they've been on many sets with many photographers, shooting with all types of subjects. Do not be surprised if you encounter generous amounts of snotty attitude from people "in the business," primarily the world of actor/model talent. The level of pretentiousness can be sky-high; but of course, there are those who are perfectly willing to help out someone wanting to break in (finding them and sorting out the ones who genuinely know what they're talking about could be the biggest challenge). When your work reaches a quality level where you feel comfortable becoming a "testing" photographer, try to coordinate a test or two with a local talent agency or theatre company. There are only so many agencies in a given market, and you shouldn't approach them until you feel your work can compete with national-quality headshot and promotional photography. You need to make a good first impression with your portfolio, so don't waste your time or theirs until you're absolutely ready. The worst thing you can do is act as if you are a professional and misrepresent yourself.

BEGINNING TALENT

When you feel, or are frequently told, that you have potential as a model or actor, and you want to pursue it seriously, there are certainly pitfalls to avoid. There are lots of supposed "agencies" and "photographers" out there who would certainly take advantage of you by implying you have great potential, you're perfect, you'll get lots of jobs, blah blah blah. They usually want to sell you packages of classes and/or headshots, or take advantage of you personally. There is a lot of posturing going on in the world of photographers who pretend to be plugged in to the world of modeling and acting. Your ego needs to step back and get the big picture. You will not really know if you have true potential until you get into a professional photo shoot with a photographer who has experience seeing talent succeed and fail. Having "the look" is one

thing; it's an entirely different thing altogether to project a dynamic on-camera energy, take and follow directions, and deal with rejection. Stage experience is great to have, though I have shot many veteran thespians who struggle with a one-on-one camera experience. Look at pictures of successful actors, models, and lifestyle models in magazines, print ads and catalogs; look at the energy they're projecting, the expressions, and the body language. Can you do that? Perhaps most importantly, you should be able to distinguish a big difference between the idea of "celebrity" and a genuine craft of conjuring believable expressions.

WHEN DO YOU NEED PROFESSIONAL IMAGES?

For actors, if you are competing in the world of theatre, film, television or commercials, you need a professional headshot, period.

When you sign with a talent agency, they will probably require you to get professional headshots (if they don't, I'd question their integrity as an agency). It is usually not necessary to have one to submit to and audition for agencies, but it certainly makes a better first impression when you hand in a professionally done headshot with a resume. If you have done a professional photo shoot for headshots, it's also a good idea to have access to your proofs (digital gallery or printed proof sheets), because an agency interested in you might want to see other headshot options from that shoot.

For fashion/print models who are just getting started, most professional agencies ask you to submit candid snapshots of face and full body. They only want to determine if you are the right physical type they may need on their roster. They are looking for qualities such as beauty, edginess, long legs, quirkiness, and good body proportions, especially if you might also have potential for doing runway. For classic fashion/print/runway, women are typically 5'8" or taller with long lean legs. Men are typically 6' tall but not taller than 6' 3". It is rarely necessary to submit professionally done pictures to an agency for a potential modeling contract; they want to see you raw and unstyled. A professional shoot, however, could help you determine if you enjoy modeling, and the images can help you see what your potential might be. Having the right looks and measurements are only part of being a successful model; having on-camera energy and variety of expression and the ability to express yourself naturally is a huge part of your potential.

Lifestyle print modeling is all over the map; advertisers need all body types to portray all types of people. An agency will be honest about your potential for lifestyle print, but most actors and models would have some likely potential depending on the types of jobs available in their market. You would supplement your regular headshot with some images that show you can pull off lifestyle print looks. In most markets, on-camera talent need to cast as wide a net as possible for on-camera work; actors sometimes need to be lifestyle print models, and models sometimes need to be actors for broadcast, film and television work.

For corporate professionals, spokespersons, salespeople, realtors, politicians and anyone else needing quality pictures to project their image, you need to look beyond the standard portrait backdrops and poses. You operate in a culture where dynamic images abound, and personality and style can be fine-tuned to show you at your best. If you want to really project professionalism in order to score those bigger better clients and prospects, then you need to shoot with *professional* photographers and stylists.

No doubt by now you are thinking "OK, I've heard enough of the word *professional*." The difference between that and "amateur" can't be underscored enough; and there's a lot of amateurs out there, as you'll see in the next section.

FREE SHOOTS, TFPS, POSERS AND SCAMS

As an actor or model or start-up entrepreneur, you're probably not making a ton of money, and it's understandable that you would be attracted to offers from testing photographers for "free" shoots, or you'd shoot with your friend who's interested in photography and wants to try their hand at it, because "how hard can it be—isn't it just a shot of your head?" Or, you get suckered into working with some photographer who claims to also be an agent, or some "agency" that sells a headshot "package." These scenarios give literal meaning to the term "crap shoot." Not that the images from these shoots are terrible (though they frequently are); but the photographers don't likely have the experience within the industry to produce headshots that will get you results.

Here's the bottom line: if you want to be considered a professional actor or print model, you need a professional headshot or portfolio images. You usually don't get professional services for free. There are networking sites that link "photographers" and "talent" all over the internet. Many charge for subscriptions, some are free. There are some surprisingly good photographers out there who have not entered the professional world yet and are looking to break in; they shoot for free in order to gain experience. Many—even some professional photographers—see headshot and portfolio business as a temporary step toward their goal of being a hot new commercial or fashion photographer. Nothing wrong with that—they have to start somewhere, right? See the previous section on photographers getting started.

On the other side of the camera, there are tons of actors/models/performers/professionals of all varieties who just want to get in front of cameras, and they take advantage of these free offers. It's an exchange usually termed "TFP" or "TFCD," which stands for "time for prints", or a compact disc with images from the shoot burned onto it. The talent gives their time, the photographer gives prints or a CD. However, none of this does any good if the images aren't marketable and the talent doesn't really know what to do with them anyway.

Of course there are exceptions, and some of the photographers at this level will indeed move into the professional world; but there are also many who prey on vanity, and a considerable

chunk of these exchanges turn into pressure for nudity and/or implied nudity. As importantly, who knows how many unsuspecting actors/models images shot during these sessions are sold as stock footage around the world without their knowledge?

If you want to become professional, you will need to invest in yourself and your potential: work with professionals (in case you're keeping count, the word "professional" is used 186 times in this book).

WHAT IS A HEADSHOT?

Back in the golden age of "movies" and the advent of television, headshots captured actors at their most glamorous, making the talent seem larger than life, as they would be seen on the screen; since the early days of photography, world leaders and local mayors alike have sought out images that projected themselves as leaders—confident, stolid, strong—and if they were lucky, attractive. These days, movies and TV shows offer regular doses of gritty reality (while "reality TV" shows offer regular doses of concocted silliness). That modern edge is reflected in today's variety of headshots. The headshots you see on leading talent agency websites, even the creative portraits of celebrities and professionals in the mainstream media, still have one goal in mind: to sell that person to the viewer.

There's no singular definition of a headshot, but there are a lot of very accurate descriptions of what a headshot *should* be:

> ▶ A headshot is an instant audition.
>
> ▶ It's a visual resume of your physical energy, showing how well you project expression and presence.
>
> ▶ A headshot is essentially product photography—and the product is a personality.

No two casting directors or agents will describe a headshot in the exact same way. The only thing they can truly agree on is that they know a good one when they see it.

Headshots are used by agencies, casting directors, producers, casting websites, and marketing and advertising professionals to determine if the person in the shot looks right for the role for which they've been submitted. Whether you're submitting for an extra role or feature role, you need a headshot.

Your headshot will often be seen online, or be reviewed without your presence. It needs to speak *for* you. It will be judged without regard to your written resume. You have to pass the headshot test before they even look at the resume.

The average length of time a casting director looks at most headshots during the initial casting? Less than 1 second.

What can make you stand out from the 300 other headshots being reviewed for the role?

Assuming you have submitted your headshot for a role that matches your general physical type, what dynamic beyond that look can give you an edge? Most casting directors will tell you it's an energy in your eyes, a hint of personality, or perhaps some extra "spark" that captures their attention.

A headshot is not a "glam shot," making you look fabulous, like a "movie star." Professional headshots must be visually *honest*; they're best when they capture a mixture of personality, dynamic energy, and of course they must show the physical type for the role. It has to look real; if the photo is too lush and beautiful, like overprocessed magazine quality shots, it's gone too far.

A headshot is not necessarily a fantastic photograph. It does not need to be artistically engaging; it does not necessarily leave the stamp of the photographer. You should never

> A PORTRAIT CAPTURES A PERSON. A HEADSHOT SELLS A PERSON.

see the *picture* before you see the *person*. It's a sales tool, a marketing piece. Great photographers are not necessarily great headshot photographers—a headshot is essentially a product shot, and that product is a personality, a body, a face, an expression. It is most definitely NOT a portrait. Photographers whose primary business is portraits might end up using portrait tricks, lighting and poses that are great for kids' school pictures and families but terrible for selling talent who need to come across as natural. A portrait captures a person. A headshot *sells* a person.

One of the most important elements the photographer brings to a headshot session is the ability to direct the talent to capture a variety of expressions, to bring out an inherent natural energy, and to capture what the talent's "type" calls for.

In terms of cropping and framing, a headshot is typically cropped in to head/shoulders, but many types of headshots need the option of seeing body type. During a typical headshot session it's ideal to shoot close-ups, chest-up, waist-up, and 3/4s (down to knees). On-camera talent are hired for a variety of reasons, from hair color, skin type, to body type. These all need to be captured accurately and honestly. When shooting a headshot session, whether for actors, models, or business professionals, I usually give them options in terms of facial angles, body angles, close-ups and full body shots.

COLOR OR BLACK-AND-WHITE?

It's hard to imagine that in the 21st century, this question is still asked. The answer is simple: COLOR. You may sometimes run across a student submitting to an academic program which

requires black and white headshots. Community theatres often seem to want black and white headshots (could this be because a lot of older actors have not updated their headshots and don't want color headshots to upstage them on the playbill?) If you're still submitting black-and-white headshots, it's a clear sign that you're either a community theatre actor and/or you haven't updated your headshot in a long, long time.

Since the vast majority of photographers shoot digitally, any shot can be easily converted to black and white if necessary. This is sometimes appropriate for stage actors or for promotional pieces that will be printed in black and white and need to be delivered print ready. But for all others, the world is in color, the technology is in color, the actor is in color: it's COLOR.

HOW DO YOU KNOW IF A HEADSHOT IS WORKING FOR YOU?

You'll get jobs.

Of course, you'll have no way of knowing that your headshot itself is working *against* you, because no casting director has time to write letters to everyone who auditions giving them pointers on their headshots, style and energy projection. If they did, most such letters would read something like this:

> *Dear Actor,*
>
> *Thanks for your submission. I hope your day job is going well. Best of luck!*
>
> *The Casting Team*

Assumably, you or your agent have submitted your headshot because you are the general physical type or age range for the role. At the initial stage of headshot submission, your level of acting experience probably has nothing to do with your potential in getting the role, and won't

AVERAGE TIME IT TAKES A CASTING DIRECTOR TO MAKE THAT DECISION? ABOUT 1 SECOND.

even be considered at this point; the headshot is the first thing the casting director will see and consider, and it's the headshot that will decide whether you advance to the next level of consideration. Average time it takes a casting director to make that decision? About 1 second.

Here's the bulleted, attention-span friendly list of things that make and break a headshot; if you are surreptitiously taking cellphone camera shots of any pages so as to avoid purchasing this book, these would be the ones:

Technically, a headshot...

ARE YOUR HEADSHOTS WORKING?

HEADSHOT KILLERS:

- If you present a headshot that doesn't really look like you in person (have you waited too long to update?), changed hair color, gained or lost weight, or are you now wearing braces? Those are all "must" reasons to update the shot.

- If your headshot looks overly retouched (a little overzealous in getting rid of those eye bags and crow's feet?)

- If your headshot is cheaply printed or reproduced (drugstore kiosks and discount store print services often do not use professional grade photo paper, they use thermal laser imaging or other processes)

- If your headshot is decorated, uses a cutesy font for your name or contains desperate text such as "please please oh god I want this role."

- Images that are overly sexy, cute, posed or "hiding" (showing only one side of the face, angles too extreme to get a sense of face/body type)—this screams "lack of confidence" or "overreaching."

- If your energy is DULL DULL DULL

- Background is too busy or elements in the composition compete with the viewer's attention

- If you see the picture before you see the person (if the picture is so lush, beautiful, dripping with gorgeous light, etc)

- Talent is wearing too much makeup, has outdated hairstyle (or is overstyled)

- Too sexy or salacious; talent is vamping or trying to look overly macho/stoic

HEADSHOT SAVERS:

- A great natural smile and spark
- Eye energy projected right into the lens
- An expression and energy that convey realism, character, intensity
- Natural, not overstyled!
- Composition that has sharp focus on talent's eyes and lets the backdrop fall out of focus
- Wardrobe and styling complement (not overwhelm) the talent.

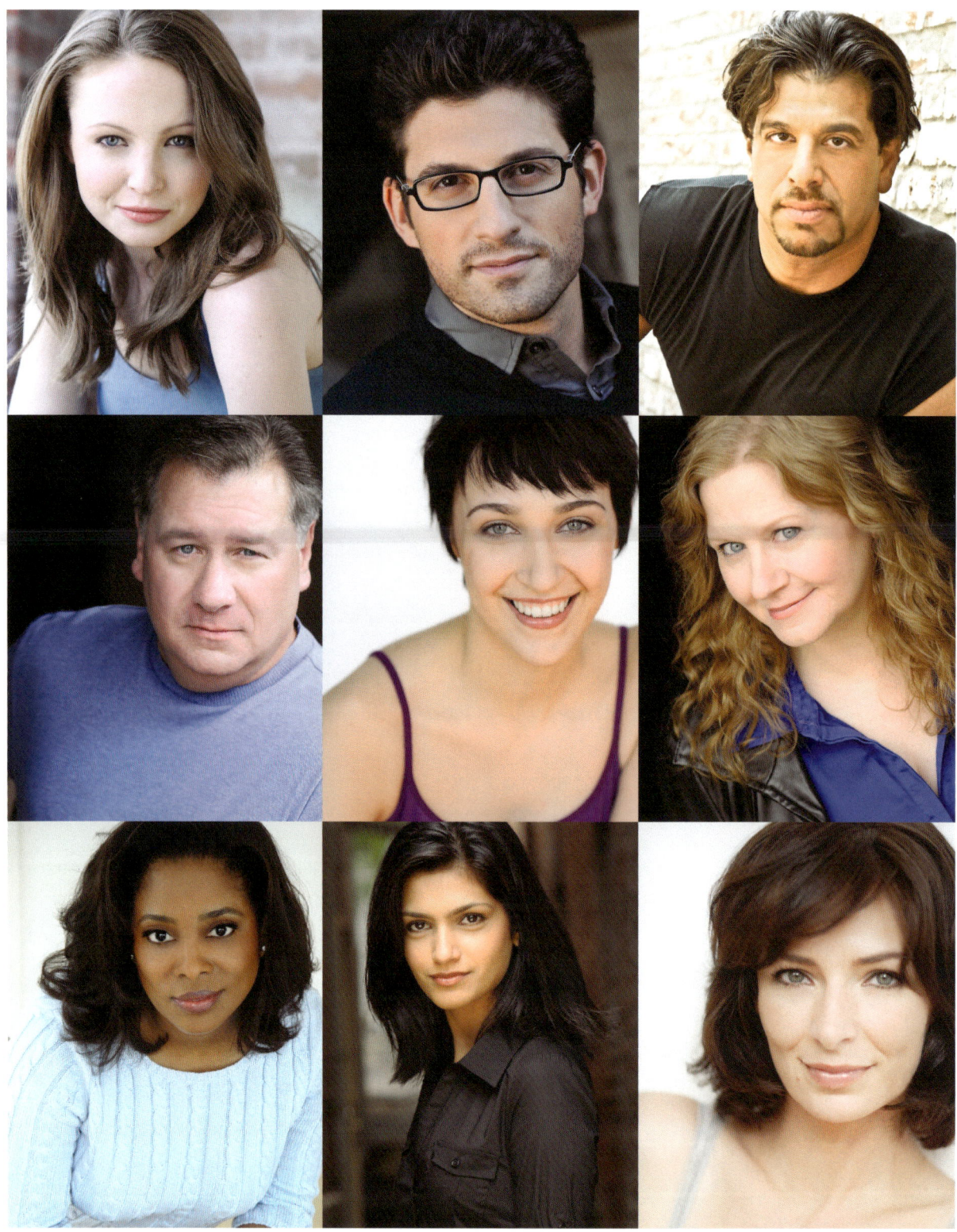

TYPES OF HEADSHOTS & PROMOTIONAL IMAGES

A good headshot can be used for multiple purposes and some talent can get by just fine with one good image (usually a "commercial" or "theatrical" headshot). Most actors and other on-camera pros, however, smartly utilize a few different headshots and "lifestyle" images which play to specific areas of on-camera or performance industry needs. The talent, their agency, and the photographer have to work together to identify the type of headshot or multiple headshots that would best market the talent's image and salability.

On-camera talent, whether actors or models, need to leverage their abilities if they want to be considered for the wider variety of on-camera jobs within their market. In the current demand for lifestyle advertising and stock photography, actors need to be models and models need to

> IN THE CURRENT DEMAND FOR LIFESTYLE ADVERTISING AND STOCK PHOTOGRAPHY, ACTORS NEED TO BE MODELS AND MODELS NEED TO BE ACTORS.

be actors. The fashion world still prefers gorgeous six foot body-fit models for runway, catalog, and top fashion shoots. But more and more catalogs and lifestyle products are marketed to "regular" people, and a variety of people are needed as on-camera talent for both commercial broadcasting jobs as well as print advertising. All ages, all body types. The key is that you have good "camera energy," and a good headshot or promotional lifestyle shot is what sells that in advance.

It's rare that an individual talent will need every kind of look, though some with a wide range of ability and looks would be smart to have as many of these type shots as possible. It would certainly be too difficult and time-consuming to do them all within one session (or even within a day). I tend to shoot commercial and theatrical looks, and perhaps corporate looks, within one session of a few hours, allowing time for the styling and wardrobe changes. Lifestyle and portfolio looks take much more time and often involve moving from location to location to get the variety needed, and that usually requires a longer stretch of time.

COMMERCIAL HEADSHOT

Conveys good general commercial energy, usually with a great natural smile. "Commercial" generally means commercials for advertising, either in print or broadcast (television). In the professional world, this is the most common and universal type of headshot needed. Usually very bright with a cheerful, confident energy.

TYPES OF HEADSHOTS & PROMOTIONAL IMAGES

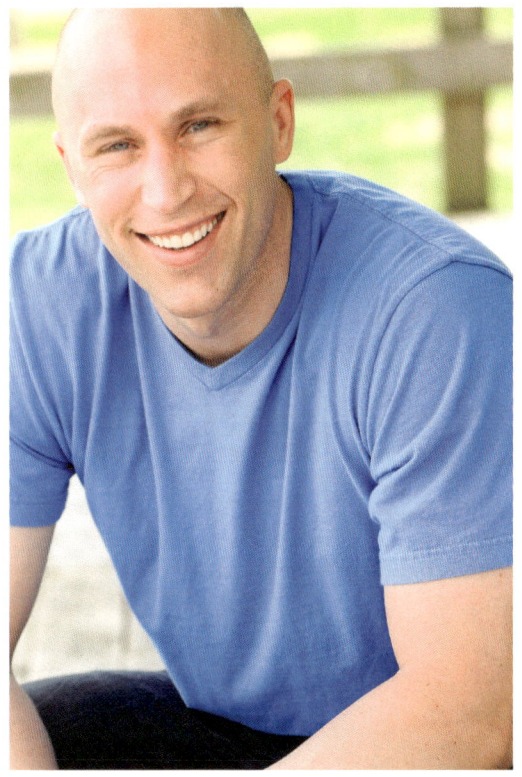
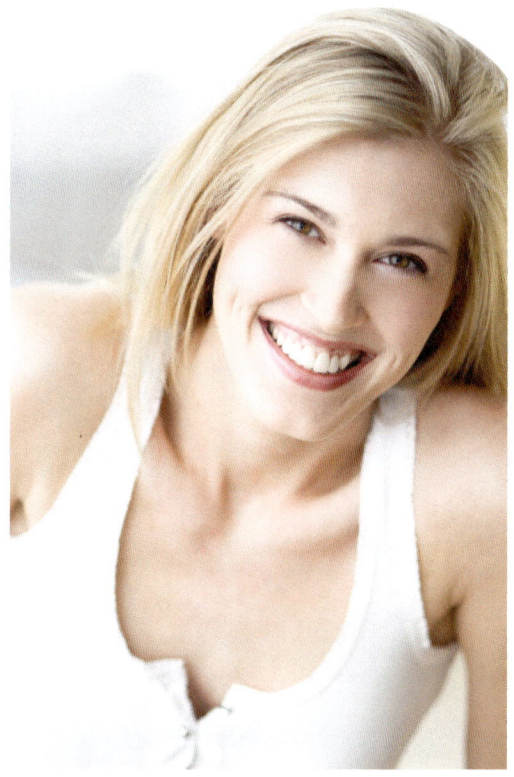

THEATRICAL/FILM/TELEVISION HEADSHOT

In the biz, "theatrical" means film & television. Headshot images can show a range of great natural smiles to more subtle, dramatic expressions. Think promo shots for characters in dramatic film and television series roles. Compositionally, on the darker side with a little more intensity.

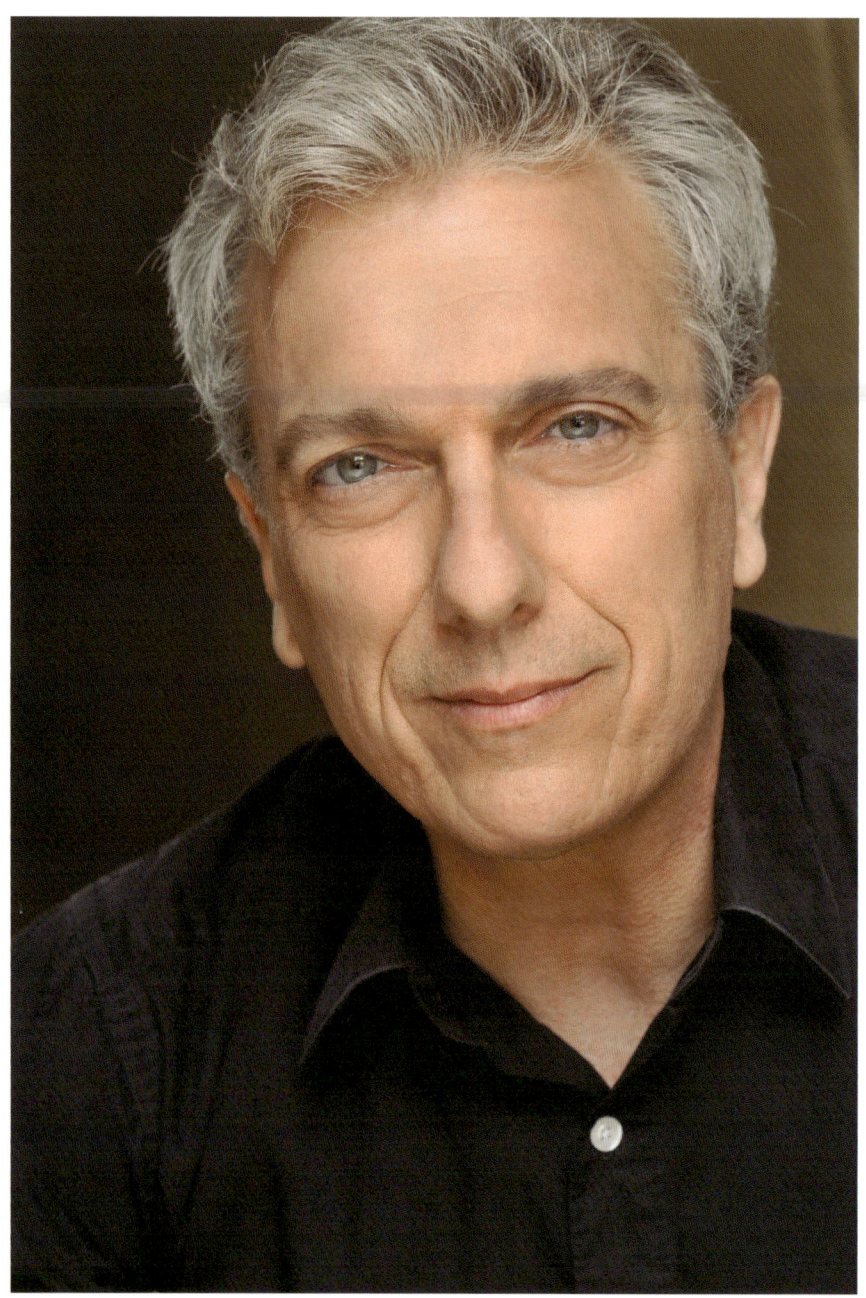

TYPES OF HEADSHOTS & PROMOTIONAL IMAGES

THE ART OF THE HEADSHOT 37

COMMERCIAL/THEATRICAL JUXTAPOSITION

Most talent need both commercial and theatrical looks; here are some examples of the different results on the same subject:

commercial

theatrical

commercial

theatrical

TYPES OF HEADSHOTS & PROMOTIONAL IMAGES

commercial

theatrical

commercial

theatrical

THE ART OF THE HEADSHOT 39

COMPARATIVES: SAME GIRL, 3 DIFFERENT HEADSHOT TYPES

Film/theatrical headshot

Actually shot in a 4-ft wide brick alley, talent squatting on the ground; her expression is dramatic and the eyes are locked into the lens! The brick walls on each side add a touch of warmth on her skin and add a hint of ambience.

Stage/theatre headshot

Shot in natural light in a parking garage so the background grays out nicely. She does a lot of dramatic theatre, so her headshot reflects that. Tones are more neutral as this will likely be converted to black-and-white in theatre programs.

Commercial headshot

Great natural smile, shot in natural light against a blue-painted shed. She's wearing a slightly brighter blue tone and the cut of her top helps force the eyes right up to her winning smile.

TYPES OF HEADSHOTS & PROMOTIONAL IMAGES

COMPARATIVES: SAME GUY, DIFFERENT LOOKS

With and without beard; much younger looking!

Two very different shots for commercial, comedic roles, and one for serious, dramatic roles. The hair change helps him play to an edgier type.

THE ART OF THE HEADSHOT 41

CORPORATE/PROFESSIONAL/INDUSTRIAL HEADSHOT

On-camera talent will often be hired as a host or spokesperson in a corporate advertisement or intra-company training video known as an "industrial." Talent being submitted for these types of roles usually need a shot that conveys confidence, friendliness and professionalism, and they should be dressed conservatively in a contemporary suit or a smart, contemporary casual option.

Corporate headshots for executives, broadcasters, self-employed professionals and others needing self-promotional tools for press releases, websites, and general promotion and publicity should be styled according to their company's general dress codes, or however conservative or casual they want to project themselves.

AUTHOR/SPOKESPERSON HEADSHOT

A headshot that conveys a sense of confidence, authority and professionalism or artistic sensibility works well for authors and spokespersons. Styling is usually more toward the subject's personal style, or how they appear in public or at events. If an author wants to play up a certain genre "style," such as Anne Rice looking dark and gothic or Danielle Steele looking all soft and glossy, that's a discussion to have before the shoot. They need to be able to pull it off with how they project their energy or risk looking cheesy. I could spend a lot of time dissecting the images of bestselling authors I see on dust jackets; especially those of the self-help category, where more than a fair share of them are ridiculously over-retouched; does anyone not see the irony in someone who's a supposed expert on "claiming the real inner you" when their headshot is the epitome of fakery? Don't do that.

Since many corporate and promotional headshots are used on websites and brochures, I prefer to shoot them with solid-colored/neutral backgrounds so they don't compete with busy text and art.

PAGEANT HEADSHOT

Pageants have traditionally been styled, jeweled and glamorous—too much so, actually. The growing trend now is to keep the styling and makeup on a more natural side, with the "big hair" days on the wane (though many pockets of resistance and old-school thought persist!), and no over-retouching. Not terribly different than a good actor or model headshot, but there is still a sense of glamour and beauty that needs to be incorporated. The *beauty* is still key, though any contestant will quickly straighten you out on what these pageants really exist for…scholarships and opportunities. Finding a girl's natural energy and just enhancing her natural beauty will make for a winning pageant headshot. Professional styling is, of course, vital to a pageant headshot.

There are countless pageant systems in the United States, though the two most well-known systems are the Miss America and Miss USA systems. Each produce annual local and regional pageant contests in every state. Depending on the system, the specific contest, and the age range, some contestants need headshots, and may need sash and swimsuit options. Winners of each level usually need "gown and crown" promotional shots and perhaps new headshots to advance to the next level. Some pageant directors have more stringent requirements for their contestants, so you will need to check in with the director of the local pageants. You can usually find such contact information by going to the main Miss America or Miss USA websites and drilling down to the local pageant contact information.

TYPES OF HEADSHOTS & PROMOTIONAL IMAGES

An entry headshot is the first thing a pageant judge sees; it needs to project natural beauty and sincere expression.

Crowned winners need images for signature cards, pageant websites, and state promotions

THE ART OF THE HEADSHOT 45

BODY SHOTS

Some talent have certain body types that are marketable. A guy who's beefy and in great shape should display that in a body shot; a voluptuous woman should accentuate body form in some of her shots. Print models would typically need body shots, but even actor headshots can convey a sense of body type. Tight tee shirts/tank tops and denim are good bets for body shots, swimwear is best left to fashion and swimsuit models. However, don't get sexy and artistic; the bodies must speak for themselves. A body shot does not necessarily have to be "head to toe," rather, it is framed and cropped in such a way as to accentuate the body type.

A lifestyle body shot that landed this girl a nice job with a large beer ad campaign

The classic "shirtless guy;" strong muscle tone is best captured with plenty of contrast

BODY/FITNESS

Lots of markets seek talent for fitness shoots; images of people leading active lifestyles such as biking, playing tennis or golf, handball, jogging, working out. It's just important to remember in setting up your shots and directing the talent's energy that you are not selling the activity itself, rather you're showcasing the talent engaged in the activity. Successful lifestyle fitness images show fit people of all types enjoying some kind of physical activity, or looking as if they're taking a pause from that activity.

LIFESTYLE SHOTS

Actors and on-camera talent are often submitted by their agencies to do print advertising or lifestyle modeling. Since advertising caters to all ages, sizes, and types, they need to reflect those ideals in their ad campaigns. Actor headshots alone don't always suffice for getting these types of jobs; a print look or two that caters to a talent's lifestyle "type" can be very helpful in the on-camera talent's arsenal of images.

Both talent and photographer should be familiar with the major advertising clients and catalogs in their region, because that's who the model—either independently or via their agency—is being marketed to. Agencies know their top clientele and who might hire your type, so catalog and fashion looks should take that into account. Know your market and play to it (but never show product or "pander" to a specific client in these images by matching a specific ad). Shooting images that emulate catalogs and fashion advertising is classic print modeling; though these images are selling *you* as a model, *you* must be convincing as a *model* who can *sell* the wear (or the bag, or the jewelry, or the chinchilla). If you are tempted to shoot "high fashion" (the types of fashion images in top fashion magazines), then see "Making a Fashion Statement" in this chapter.

A lifestyle "look" can incorporate a lot of different elements, but it's usually a "caught in the moment" energy showing the talent doing something in their demographic "lifestyle:" sitting at a café, walking down the street, interacting with another talent (a child, a boyfriend/girlfriend, a dog). It's the type of photography you see in a lot of ads and stock images that sell lifestyle product or services. It shows they can project that "on the go" and "in the moment" energy and helps advertisers and clients imagine the talent in their ad.

TYPES OF HEADSHOTS & PROMOTIONAL IMAGES

THE ART OF THE HEADSHOT 49

PERFORMER (THEATRE/STAGE/MUSICIAN) HEADSHOTS

For stage performers, musical performers and other on-stage talent, commercial/theatrical headshots can work fine. If I know they will be used primarily in programs and websites, I'll shoot a variety against a solid white or black background so that they don't compete with other visual elements on the page.

A classic, clean headshot for a versatile stage actress.

Theatrical headshot with dark background.

TYPES OF HEADSHOTS & PROMOTIONAL IMAGES

In doing headshots for musician CD covers and promotional websites, I like to capture a sense of their own style. These sessions are usually to capture a wider range of images than just headshots, and can be as creative and artistic as the artist desires and you are capable of). Capturing a good headshot for press kits and web avatars, though, is essential.

Classical musicians and singers also need shots for programs and websites. Why must we show their instruments? It's more fun!

MODEL HEADSHOT

Models and talent working primarily in print (catalogs, fashion, lifestyle) will need a model headshot that usually accompanies other full-body images for their print portfolio (usually kept in a hardbound 9x12 book). The model headshot is often more styled than a commercial/theatrical headshot. It emphasizes beauty, of course, facial features, good projection of expression and some sense of style. Inversely, some models benefit from a headshot that is totally sheer and natural with little or no makeup—which is the current trend on younger models in development with agencies. See the "Making a Fashion Statement" section in this book on how best to photograph models who are in development.

TYPES OF HEADSHOTS & PROMOTIONAL IMAGES

THE ART OF THE HEADSHOT 53

MAKING A FASHION STATEMENT

What most people think of when they think of "modeling" is high fashion—the beautiful runway and national fashion magazine icons of *Vogue*, *Glamour*, Victoria's Secret and the like. These Venuses and Adonises populate catalogs, advertisements and runways, and their bodies, skin and hair have been royally scrutinized. However, more and more advertising and general lifestyle modeling features "real" people. It's important for a photographer and on-camera talent to understand the difference between "fashion" and other types of modeling. "Fashion" is an attention-getting word that is too easily misused.

Many photographers, professional and amateur, will say they shoot "fashion." Fashion is subjective, right—all in the eye of the beholder, whatever's popping off the pages of the fashion magazines? Yes, in general that's true. However, in the marketplace where potential models begin shooting portfolio work, fashion (and the model's particular marketability) is very much in the eye of the agents and clients who book them, and if the photographer is not plugged into the local market and to some extent, the national scene, then that photographer should probably abstain from calling themselves a "fashion" photographer. It just smacks of egotism and pretentiousness. I hereby submit that only those photographers working with top national agencies and who do national fashion magazine spreads and fashion editorial work get to call themselves "fashion" photographers. You shoot "fashion" if your images are intended to sell clothes and fashions; when you shoot portfolio images, you are shooting a "model." Good enough?

People who are likely to become real "fashion" models are probably going to be between the ages of 15 and 24, with long, lithe bodies, beautiful skin and other physical attributes we worship and love to hate at the same time. These potential models are generally scouted, discovered, and signed by agencies and put into "development." They are usually directed to shoot with photographers that their agency has relationships with. Depending on their location, they may be developed for local markets and/or other, larger markets (Los Angeles, New York, or Europe).

Photographers wanting to do "tests" with fashion models already in development with agencies generally do so on a "test" basis, which usually means for free, at least to start. When and if an agency decides they like your work and would continue working with you, they may negotiate a fee structure. Some agencies may pay this directly, and some may have the model pay the photographer and stylist directly. The degree to which you are published in fashion and editorial magazines will have a significant impact on your negotiability. Development and testing of models with real potential in the fashion world is big business—but not for the photographer or model (yet). It's about positioning the model to attract the big contracts

MAKING A FASHION STATEMENT

Images from model test shoots; simple wardrobe & styling.

THE ART OF THE HEADSHOT

with big brands who are always looking for fresh new faces and bodies. This is sometimes accomplished from a snapshot; sometimes from years of portfolio shoots.

Despite the glamour and luster of "fashion" photography, neither photographer nor model are really making much money, if any, from the "testing" and portfolio-building phases of their careers, even when doing fashion and editorial spreads for local fashion and style magazines. Rather, these magazines and publications rely on the vanity/aspirations of photographers and models and their willingness to work for free (or for very little) in order to gain exposure and land bigger jobs and contracts.

I point all this out to underscore that if you are a potential model, be wary of laying out a lot of money for shooting with any photographer who doesn't have any connection to legitimate agencies or publications; even if you get stunning images to present to agencies to land a modeling contract, they may well request that you shoot with their photographers anyway. Potential models should have a photographer or friend take simple digital candids of them including full body (head to toe), profiles, and close-ups (with and without smiles). See "The Candid" on page 73. If you submit these images to a variety of agencies and aren't getting any bites, it's probably time to face the music; either you're just not model material or aren't right for that market. Most agencies will be honest; some just won't respond at all. Be patient—and be realistic.

MAKING A FASHION STATEMENT

Images for model portfolios where the emphasis is on the model's body and energy, not wardrobe or fashion

THE ART OF THE HEADSHOT 57

CHILDREN

Kids are hired for their energy and cuteness—and capturing that is essential. But you shouldn't need cheesy props (a staple of bad portraits) or accessories to achieve that look. However, for kids, you can get away with brighter colors, louder energy and over-the-top cuteness—but it must read *real*. The kids should be able to produce that level of energy on their own, but certainly need some direction in channeling the energy.

Again, professional headshots are not a necessary investment for children under 4 or 5 (depending how much older or more mature they may look). Good snapshots showing their expressiveness usually suffice for most submissions. However, kids from 4 or 5 up through puberty need headshots updated with some frequency, as they are changing and growing.

When photographing children who are potential on-camera talent, I first like to assess just how natural they are in front of the camera. They usually don't have the self-consciousness that adults will have once that lens is raised and focused on them. They essentially know they're "performing" for the camera, but what will they do? Do they bring their own energy, or do they stop and wait for direction? Do they bounce off the walls and shout profanities at you? Do their parents stand behind giving them hand signals? You'll find this out pretty quickly and take cues from them as to how to direct their energy. If kids clam up in the studio, I take them to a playground, or bring out the mini-trampoline, or pump up the fun music, and get them in their comfort zone. I might stop shooting altogether and engage with them a bit, talking about their favorite things. I keep the conversation going and lift up the camera and shoot as we're talking, leading them with questions designed to provoke expressions.

Another important element with on-camera kids is seeing how well they do with their parents out of the room. When they do get jobs, parents are typically not allowed on set; kids need to have an ability to work independently and take direction from you without mom or dad echoing over your shoulder (which is incredibly annoying and never allowed on my sets). If a child has just been signed with an agency because they are just so gosh-darn cute, then it sometimes falls to the photographer to determine how well they perform on camera; if a kid is shy and reticent to take direction, the photographer should be honest with their parents (and you will almost always hear the excuse that it's just a "bad day"), and of course, their agency. The agent wants to know if the kid is ready to take on professional work. It is always prudent, of course, to be sure you have a stylist present with you.

Photographing younger children (4 to 7 or 8) can be a pretty fast and furious affair. Though it's a huge asset to their potential career that they have patience and a willingness to take direction, you will usually capture their best, most natural energy by winging it and improvising

CHILDREN

in the moment. They will tire of the shoot, tire of changing clothes often, even tire of smiling. I put the brake on the smiles and try to capture lots of expressions from angry yelling to bouncy zaniness and everything in between.

I do sometimes find that I have to "unteach" kids some bad camera posing habits; they may have been instructed by well-meaning adults to "smile big" or "put your hand on your chin," or they could be mimicking some terrible pictures they've seen, or their only experience on camera has been the nice portrait people down at the mall who tell them to do these things. Kids in dance classes often have 'pose' and unnatural posturing drilled into their bodies. Don't succumb to these evil portrait temptations.

LIFESPAN OF A HEADSHOT

I often see people who stretch the life of their headshot for years, mostly because they are aging and feel their old headshot preserves their younger-looking persona (all you reverse Dorian Grays, you know who you are). Or, they're broke and can't afford new shots. Kids especially need shots updated more frequently as they grow, bodies mature, braces go on/off, hair changes and confidence grows. Everyone is on their own growth pattern and has their own ever-changing optical range, so you need to gauge when changes are prominent enough to warrant the investment in new shots.

Of course, your headshot is only good when it looks like you. If you change hair color, get a mohawk, gain/lose significant weight, or have Maori tattoos put on your face, time to get new shots.

Here's a helpful chart to use as a general guideline:

Ages 0 – 4 professional headshots aren't really necessary; most agents can work with updated snapshots of infants and preschool children

Ages 4 – 8 every 6 months – 1 year

Ages 9 – 12 every 12 – 18 months

Ages 12 – 16 every 12 – 24 months

Ages 17+ every 2 – 3 years

One reason to update your headshots frequently is that, in many markets, your shot will repeatedly be seen by the same handful of casting directors. If your headshot's working, great— but it's a good idea to let them see you in a fresh light.

THE COST OF HEADSHOTS AND PORTFOLIOS

Images are the single most important investment on-camera talent will make.

The key word here is "investment." It's the talent's goal to make this money back and more in getting jobs from the images created. Talent will also be able to deduct costs associated with getting images (session fees, some wardrobe, styling, etc). Of course, you will need to consult a professional tax advisor for handling such deductions legally and properly.

When you are trying to sell your talent and image professionally, you are a product (congratulations!). You are your own little corporation. Just like any business enterprise, you require investment, maintenance, marketing and some overall business planning. Headshots, portfolios, makeup/styling, and print/digital media are going to be a big part of your expenses.

A general word of budgeting advice for talent: make sure you have the capital needed for the whole process, from the consult to getting the print reproductions and/or promo cards. If you get the pictures taken, then wait months until you're able to afford print reproductions, you're losing some value in your investment, and I can practically guarantee that a big important audition will arise at the last moment and you will be kicking yourself for not having your great new headshots on hand (or you'll be begging the photographer to get one printed fast). Ordering your headshots and other prints or promotional media as soon as possible helps secure your investment.

COSTS

It varies from market to market and photographers can be all over the map in terms of the nuts and bolts of what exactly they provide for their fees, but below is a general range of photographer, stylist/makeup artist, and print/processing fees talent might expect to pay. Most sessions are divided into "looks," which are different wardrobe/styling/location setups. The more looks you shoot, the more you should expect to pay.

What is a reasonable price structure to expect? I list some general price ranges below, based on a sampling of headshot photographer services posted online from coast to coast.

Some photographers separate their studio or shooting fees from their processing and retouching fees, some will include a certain number of images and others will provide an ala carte offering. Further, some may or may not include hard copy proofs or prints. You need to be clear with each photographer as to what is and is not included in your session.

It's very important to realize that the photographer owns the rights to the images. He may allow a free and liberal usage of select images, or may be willing to provide you with a CD (or make available digital images via a download or online service) of select images and a copyright release giving you permission to have them printed (most commercial printers will require this permission). Many who hire headshot and portfolio photographers wonder why they don't just get a disc of all images, after all, you paid for the session, right? Again, you

PHOTOGRAPHY & STYLING

- Consult/Pre-meeting — $0 -- $50.00
- Studio/photography fee — $50 - $200 per look
- Makeup/styling (sometimes more for women) — $50 - $150

PROCESSING & RETOUCHING

- Processing/proofs — $0 - 50
- Retouching — $10 - $50 per image or $50 - $100 per hour

PRINTS & MEDIA

- Headshot reproductions (depending on quantity needed) — $50 - $300
- Comp cards (depending on quantity needed) — $50 - $300
- Digital images — $0 - $50 each

have to think professional. Do you, as a professional talent, want a client hiring you to use your image repeatedly and with no recourse or compensation to you? No! You (or more likely your agent) negotiate usage and/or buyout rates for the use of your image. A professional photographer is doing the same thing. This is a business. It's not like getting the family portrait or senior pictures from the nice portrait photographer who gladly makes a CD of all images part of the "package."

As a photographer, it behooves you to separate your time/shooting/studio costs from any print media costs. They are two distinctly separate things; in some states, shooting is considered a service (like plumbing, or pyschotherapy), and may not be subject to a sales tax, whereas prints or discs are tangible media and would likely be taxable. Know the tax laws in your state and your county; check with your accountant.

FINDING A PHOTOGRAPHER

As you search for a photographer, you will quickly find there's a wide variety of experience and inexperience. So many emerging photographers, whether students or mid-life "startups," gravitate toward "fashion" and headshots because they believe it's sexy and glamorous. Few can get into the doors of legitimate agencies because their work isn't professional caliber. But they post on talent websites and social sites, offer shoots for free, and may even use some level of deception to come across more professional than they are. They may even have some really impressive camera equipment or access to a cool studio. It's easy to create a business card or put listings on actor and model websites proclaiming themselves "fashion" photographers or "headshot" photographers, since most of those sites do not vet the professionalism of their subscribers.

Some actors or models—especially those in small markets—will go to their local photography studio, which is usually a portrait studio, and inquire about headshots or portfolio images. The photographer may do fine work in portraits, student portraits, family portraits, or weddings, and would do the portrait treatment for headshots, which doesn't usually work. You need to ask the photographers if they've ever done headshot work (more specifically, the type of headshots you are needing), if they've worked with professional agencies, and if they can show you images they've done for actors and models or businesspersons. If they can't produce these kinds of samples, move on.

If you come up empty in your local market, you may need to consider a trip to your regional metropolitan hub, where there is a concentration of professional and commercial photographers.

You can usually get good recommendations for legitimate headshot/portfolio photographers from local talent agencies (be cautious of talent "schools" that want to sell you packages of headshots, classes, etc). If you do not have the advice or recommendations from a professional agency, you will need to do some research on your potential photographer to determine whether they're professional enough (or even safe enough) to work with. Review their website (if they don't have a website, that's kind of a red flag) to see if they have a variety of the types of images you will need. If all you see are sexy pictures of scantily clad women, there's another red flag. Good advice for women is to never go to a consult or shoot with a photographer you do not know unless you have an escort or friend with you. And if someone is fawning over you and telling you how great and sexy you are, that's generally another red flag.

Of course, the tricky part is finding a photographer who produces quality images and has some experience with agencies or the industry, but who also has a decent sense of business service

and is professional enough to get your images to you and your agency in a reasonable amount of time. Most photographers who shoot professionally have built a reputation within their city, and you can go to actor/talent/professional networking sites to ask the talent community for advice and experience.

PROBLEM PHOTOGRAPHERS

Here's a few "types" of "photographers" to watch out for. Hey shooters—recognize yourself in here? Maybe rethink your approach.

"Guy With Camera"

These guys (yes, guys—I have yet to come across a woman photographer equivalent for this category, but I'm sure you're out there somewhere) advertise as professionals and might display some decent images on their websites, but their true motivation is primarily to shoot girls in states of dress and undress. If you review their websites and portfolios and see mainly images of scantily clad girls (or just sexy images in general), their interest usually isn't in the professional side of the headshot and portfolio business. They may entice you with the "TFP" deal (shooting time-for-prints or a CD of images) in which they wouldn't charge anything to shoot with you, and they would even give you a CD of all your images, wow! Some of these guys try to come off as "scouts" for agencies, or even pose as agents willing to "represent" you. These players are just plain sleazy, no matter how well-intentioned or talented they may be. Avoid at all costs.

The Egotist (or, the Perfectionist)

Some photographers—even some very good ones—have a great deal of ego about their talent, their experience, the "names" they've shot, or how cool their studio space is. They may demand that you do certain things to ensure the "right looks", such as having your hair cut a certain way by an expensive salon, hiring a professional shopper to gather your shooting wardrobe for you, demanding you wear certain designer brands, even being overly rude about your weight or appearance. They may be a great photographer, but they're out of touch with the basic needs you're paying them for. They may go on and on about the latest fashions. Headshots and portfolios do not require over-the-top styling, high fashion looks or artsy approaches. Their approach is more about projecting their ego than getting what you really need. Your headshots and portfolio convey YOU. If a photographer is overly bullish and doesn't seem interested in capturing "real," then they probably aren't your best choice.

The Portrait Artist

Good portrait or wedding photography is its own art, and some photographers are masters at it; but the energy and dynamic that goes into that great portrait for mom and dad's fireplace

mantles and wallets is not necessarily good for professional headshots. Cookie-cutter poses and ready-made sets, backdrops and props have no place in a good headshot or model portfolio. The local portrait studio is often the first place actors will call about getting headshots, especially in small markets where there aren't a lot of professional photographers or agencies, and portrait photographers understandably don't want to turn down headshot business. They just don't often understand the unique needs of headshots and might not have worked with any professional agencies or stylists.

The "FREE" shooter

There's always a crop of photographers who are "building their books," just getting started and looking for the areas of photography in which they'd like to work. They are usually

> PROFESSIONAL IS NEVER FREE.

willing to shoot for free in exchange for having talent to work with (as opposed to their family, who are probably very tired of having their pictures taken). I'm not suggesting you avoid these student photographers, rather, don't confuse them with the professional shots you need. Free is great, and it's great to get the experience for you and for the budding photographer. But Professional is never Free.

FINDING TALENT

TALENT "TYPES"

Photographers don't usually have a hard time finding talented individuals or beautiful models to work with. If you're a pro or semi-pro doing this kind of work, you may be working with agencies. If not, putting an ad in the local independent weekly or on a social networking website might net you some legitimate or aspiring talent. You need to be clear about your status (i.e., "Beginning photographer looking to test headshots") and if you plan to charge anything, and what you might provide in exchange for the talent working with you.

Likewise, photographers must deal with all levels of professionalism from actors, models, and people who aspire to be either. Without some experience working with talent and the film, theatre or fashion industries, or at least working with some professional agencies, it will be difficult for you to know exactly what people need at various stages of their careers. You may work with a first-timer on camera who blows everyone away with their sheer talent and energy for the camera, and you might work with seasoned veterans who are jaded and zapped of energy, leaving you wondering how in the world they've found work as on-camera talent. You can't ever forget that first and foremost, they are a client and are paying you to do a professional job.

The previous section in this book outlining types of headshots gives you an idea of the types of marketable talent out there and what shots they will need. No matter what their type, however, talent egos come in all shapes and sizes, and always make life at the studio interesting.

TALENT CHALLENGES

Here's a list of some talent's personality "elements" that can make a shoot challenging. Helping them avoid these pitfalls is a wonderful service you can provide; constructively point out their flaws and redirect them for better camera energy to get the shot. Talent: if you recognize yourself in any of the below "types," do some work to assure that you'll be able to convey a dynamic, natural energy. Therapy is good!

Uptight with Issues!

Everybody has some body issue, or a side of their face they think is most flattering. Some get so worked up about it that they're constantly turned that way and spring right back to it even when directed otherwise. I've had women continuously put hands in front of their bellies or try to cover blemishes, or turn their heads to an extreme angle because they think their

nose would look better. I've had men who are terrified of breaking into a smile. Talent should remember this: you're not likely shooting with a professional photographer unless you have some potential for the camera, so you need to trust your photographer and stylist to find the most flattering angles. You can bring up your issues at the consult but when it's time to shoot; however, leave all body issues at the door.

The First Timer

I've shot a lot of talent having their headshots done professionally for the first time. Even some veteran talent who have played to thousands on stage will clam up once faced with the one-on-one intimacy of the camera. It's good to get a conversation going, talk about what kinds of roles they'd like to land, what work they've done; the conversation gets things loosened up, gives them something to focus on, and I often get the great shots between words; when they're speaking directly to me, I'm getting their focus and attention. They must look engaged—so engage them (rings optional)!

Muggers

Muggers are usually cutups, offering over-the-top goofy expressions, smirks, lots of banter and chatter, and usually can't stand still; it may be hard for them to take themselves (or the headshot process) seriously; they may be overcompensating. "Mugging" displays a lack of confidence, or an overbearing hamminess. I usually appease this type by playing along for some shots, then coaxing or challenging them to the more serious side. Muggers are often filled with talent and have energy to spare, it just needs to be directed and focused.

Hotties

Hotties usually start right off by "vamping" or exuding overt sexiness; pouting the lips, parting the lips, narrowing the eyes, sliding the hands through their hair, turning the face to the "best

> PROJECTING NATURAL CONFIDENCE AND SINCERITY IS THE NEW SEXY.

side." They want to look sexy—whether they naturally are or not. I shoot some for them, keeping the energy on the fun side, then get them to dial it down a bit with a sense of humor and more naturalness. Projecting natural confidence and sincerity is the new sexy.

Macho Macho Man

Some guys are so concerned with not looking anything less than stoic, cool and macho that they cannot crack a natural smile to save their life. Loosen up, guys. A sense of humor about yourself and a willingness to look goofy is a major talent. Projecting natural confidence and sincerity is the new macho.

Cuties

Cuties are (usually) children who seem almost trained (ahem, stage parents) to give over-the-top smiles and forced poses (think child pageants and dance recitals). I don't talk down to these kids; I get them talking about things they like, which helps to take their mind off the fact that I'm photographing them. They are programmed to snap on a big toothy smile when the camera's focused on them, and frankly, it's a little creepy sometimes. I'll give them expressive directions to get them refocused, often against type—or throw them off with something silly and unexpected ("see this monkey in the lens?")

PREPPING FOR A SHOOT — PHOTOGRAPHER AND TALENT

MANAGING THE EGO

Any photographer working with people must deal with how the subject perceives themselves; and a lot of people see themselves as a lot more attractive, or a lot less attractive, than they actually are. Self-perception is often self-deception. Some talent are perfectly willing to be molded and directed and expect that, having hired you to do that work for them, you'll deliver winning images that present them honestly. Some will breeze in with an attitude of "I know best" and will make their discomfort known if they don't like their hair or makeup. They can be brash and critical. You know what? I appreciate these people—they're usually right, through their experience. I especially heed their concerns if they've had on-camera experience before. But if you really feel they're being unrealistic about how they should come across or what might really work best for them, I usually shoot them the way they prefer, then shoot a few more with my own tweaking, and they can see the results for themselves during the review. Their agent can usually set them straight if they're off.

Of course, the degree of trust talent will place in the photographer is commensurate with the photographer's experience, their relationships with the agencies that recommend them, and their word-of-mouth reputation. Oh, and their own naiveté.

Photographers can pose an ego problem too. I've seen photographers who are so caught up in coming across as "hip" fashion industry insiders that they lose track of the types of images talent really need. For headshots and general model portfolio work, no talent should be forced to spend tons of money on new wardrobe or designer wardrobe—these shoots are about the talent and how the talent projects their energy for the camera. They are not clothing ads. The only product being sold is the talent themselves. Overreaching on the part of the talent or the photographer is generally frowned upon, or comes across as desperate. The photographer must be a good listener and be able to sum up the talent's needs without injecting their own artistic ego into the process.

THE CONSULT

The consult—a brief meeting with the talent (and their parents, if under eighteen)—is extremely important. It's where you get a hint of their personality and determine what kinds of images they will need. This is the time to get organized and plan for the shoot so the day of the shoot is all about styling and camera energy.

A few key things to review at the consult:

- Get a sense of personality and style (of both the photographer and talent)
- Time and date of the actual photo session
- Review wardrobe (to see colors/styles on the talent) and determine wardrobe to bring
- Hair/makeup review—how should their hair look? Does hair need to be grown out, restyled, colored, blended? Are those roots a stark contrast to the rest of the hair? How much time will be needed to accomplish hair fixes?
- Review their portfolio and previous headshots—what worked and didn't work about previous images? What kinds of headshots or looks will complement current images?
- Review tearsheets of similar looks (have popular magazines that convey images similar to what you need to go for)
- Take a studio deposit if your policy (and it should be)
- Review policies on prints, buyouts, retouching

DETERMINING OPTICAL RANGE: AGING UP AND AGING DOWN

It's not a hideous indiscretion for the photographer or stylist to ask the talent's age, no matter how young or old. Determining a talent's optical range helps decide some styling, wardrobe and makeup options.

On camera, people can appear or "read" younger or older than their actual age, and this is called the "optical range." Someone with a wider optical range (i.e., a teenage girl who's 19 but looks 14, but with a slight hairstyle change can look 24—that's an extreme example, but it happens) might be submitted for a wider variety of roles and jobs. Taking this into consideration when shooting is a good idea; sometimes, with a simple and subtle hairstyle change or a slight variation in makeup or wardrobe, you can "push" or "age down" their actual age. This gives them greater image options for submissions, and (especially in the case of aging "up" might make their headshots last a bit longer, making it a better investment for them). This does not mean that you should put pigtails on a girl (or a boy) to age them down, or try to make a teen look a lot more sophisticated by making them a little sexier or more mature looking. It's usually pretty obvious when someone has a natural optical range, and the photographer, agent and talent should discuss whether or not it's smart to do stylistic variations to capture the optical range. As always, you must make sure you get what's natural and honest and can be easily accomplished.

DIGITAL OR FILM?

With respect to all the photographers who are still working in film (or in daguerreotypes), digital is the way to go for headshots and portfolio work. The time and cost associated with film processing and proof reviewing just don't make sense in the commercial world. In the early days of digital cameras, there was still a good argument that film was superior quality; that just isn't the case anymore. I don't want letters from photographers who are working quite nicely with their film cameras—more power to you.

Camera Types

Most headshots would be shot with digital SLR (single lens reflex) cameras; the ability to interchange lenses is key. I've seen decent enough quickie headshots and candids done with a camera phone, and some great headshots done with high-end medium-format film and digital cameras, but truly, those high-end cameras are overkill for these kinds of promotional images. The phone cameras and point and shoot cameras just don't offer the focal range necessary to get the best headshot dynamic. Most digital SLRs in the pro-sumer and professional range produce images in a quality range (5-12mb per image, for example) that is perfectly acceptable. The digital SLRs are also very portable.

Lenses

I have a nice variety of lenses (I'm a Nikon guy), though for headshots I tend to go back and forth between a zoom lens (35-70mm, or 24-120mm for example) and a fixed or prime lens (an 85mm 1:8 lens is terrific). What's most important in the lens is to be able to capture fast action (those moments in between conversations, catching real personality) and to have the talent be in sharp focus and the background drop out of focus, so wide apertures are important.

File Formats

There was a day when "shooting RAW" would have meant going nude. Photographers in the digital world have a variety of file formats in which they can capture and process images: most notably jpeg, RAW and TIFF. There are pros and cons, but most professional shooters will work in the RAW format (which best captures and preserves the widest color ranges and offers more post-processing quality and flexibility). However, those are huge files, ultimately more expensive to maintain and store. RAW is most certainly the preference for commercial work, but for what headshot images are typically used for—8x10 prints, comp cards and websites—the more compact jpeg format is sufficient. Many photographers might opt to shoot RAW and convert to jpeg for portability. It's really a decision based on the photographer's workflow preferences and what other plans they may have for those images.

Candids can be color-corrected, brightened/darkened but NOT RETOUCHED!

If, as the talent, you are shooting your own candids or having a friend or family member take the shots, try to find a solid wall or outdoor background with no distractions (phone wires, wall outlets, stair rails, etc).

THE CANDID

"Candids" are often called "digitals," which is technically incorrect, as everything you shoot is a "digital." Unless you're shooting with film, which is still called "film." Candids are basically mugshots of the actor or model, taken with no makeup or styling and against a solid color background. It's a quickie shot of what they look like at that moment, and many clients of agencies demand to see them before hiring the talent (they need to be assured that the talent still looks like their headshots). Agencies often do these themselves, but I offer to do it for agencies along with the regular shoot. It's the first thing we do before getting the shoot started. Actors usually need only headshot with smile and full body candids; for models, I usually shoot some full body, close-up, and a few loose pictures of them moving naturally. Agencies vary in what they prefer for their candids, but typically you'd shoot this variety:

- Head/shoulders with smile
- Head/shoulders no smile
- Waist up with smile
- Waist up/no smile
- Full body (head to toe)
- Left and right profiles of head, bust up, and full body

If the model has long hair, do versions with hair pulled back. Make sure hair is not obstructing the face in any image.

For a younger age group of models, 13 – late 20s, I'd usually shoot a candid in a swimsuit to show body (and body flaws); you can also shoot this in good-fitting jeans and a tank top or tee shirt. These candids can also serve as "before" and "after" shots for your stylist. This is only helpful for print models, it is not necessary for lifestyle models and/or actors—though I do get requests for candids from all types of on-camera talent.

You can certainly take candids with a phone camera; in fact , the mobility and ease of emailing these images quickly make them ideal tools for the "quickie candids."

AT PEACE WITH WARDROBE

Having plenty of wardrobe is essential to a successful shoot.

Talent: whether you are style-challenged, or feel right at home in a party of fashionistas, it's paramount that you bring plenty of smart choices for each look. Your photographer or stylist should be able to make recommendations; if you are with an agency, it's important to work with them on the looks they'd like to see on you, and have everybody be on the same page to coordinate those looks.

Photographers and/or stylists will need to give directions and suggestions on wardrobe for the talent, and should have assessed their best colors and some wardrobe items at the initial consult. Still, some talent will come unprepared; I usually keep some very basic male and female wardrobe items (black tanks, colored cammies, black and grey tees) in the studio just in case.

Of paramount importance is how colors read on the subject's skin; some colors can look great in person, but read terrible on camera. Remember that the colors you wear can reflect on your skin; if you have a ruddy complexion, and you wear bright red, you might look like a lobster on camera. Though color-correction measures can improve tones considerably in post, it's best to find the right color mix while shooting. It's usually best to avoid neon bright colors, as they're distracting. The same is true for busy patterns on clothes—wide contrasting stripes, loud floral shapes, busy folds, and too much lace and frilly edgings can all be distracting. Colors that make the talent's eyes "pop," or really bring out a good warm skin tone, are best.

THE PERSONAL SHOPPER

Usually talent brings their own wardrobe, but if they're not confident about wardrobe choices, it's a good idea for a photographer to have people on call who can go shopping with them to choose the right outfits. These shoppers are often also stylists and makeup artists themselves, but not always. A good wardrobe/style shopper will consult with you on what types of looks you're going for and they will know where to take the talent to look for and try on those items and assemble the variety you need to get the job done. These personal shoppers can charge anywhere between $50 to $150 per hour; the photographer might hire a personal shopper and charge back the talent, or the talent might pay the shopper separately. If you want to work with a shopper, ask your photographer, stylist or agency for recommendations.

WARDROBE COSTS AND BARTERING

You do not have to break the bank to assemble good wardrobe for your shoot, and a photographer shouldn't require you to spend tons of money on labels and designers, unless he's shooting an ad for that label or designer. Again, the shoot is about how you wear and present the clothes, not the label itself. In fact, it's best in headshot and portfolio shoots to avoid any clothing labels or logos.

It is quite common for on-camera talent to use a credit card for wardrobe expenses, try them out at the shoot (a good stylist knows how to conceal tags) and return items after the shoot. You do need to mind store return policies, and take care of the items during the shoot (place tape on the soles of shoes to avoid scuffing, i.e.). This is a great approach if you need to bring varieties of colors in the same outfit.

I have known models and actors to have good relationships with local independent boutiques who will gladly "loan out" wardrobe for a shoot, if they can use an image or two for their own marketing; of course, the photographer must be a part of this deal, since he owns the images, and would consider such usage as commercial advertising.

And remember, the purchase of wardrobe used for portfolio shoots and jobs is tax-deductible (but of course always seek the advice of a tax professional)!

WARDROBE SUGGESTIONS

Headshots – Commercial/Theatrical

Wardrobe for headshot looks is usually very simple, not overly stylish; the idea is to focus all the energy on the expression and eyes and let wardrobe fade into the background a bit. Loud colors, busy patterns, and big logos are all too distracting. Colors should complement and bring out natural eye color. Be careful of skin tones; certain colors will reflect on skin and emphasize reds, yellows, or other colors that can be hard to correct in post. All that said, clothes can certainly reflect a sense of the talent's own personal style (unless the style itself is just too distracting).

Portfolio & Lifestyle

Looks for portfolio shots are all over the map; an agency or talent might desire a certain type of shot that emulates ads of major designers or clothing stores (simple, like The Gap, lifestyle like Dillard's, sexy like Bebe or Guess, etc). If you do not have a distinctive vision, it's best to look at the ads and the in-store images for your "type" within your department and assemble outfits accordingly. A portfolio look needs to be coordinated, possibly utilizing accessories. If you are a fashion model, then choose wardrobe and looks that emphasize long legs and body.

If you're doing a portfolio for lifestyle, choose the wardrobe for the look (i.e., soccer mom, or "out on the town").

Corporate/Professional

This look will almost always require a good coordinated suit, more on the conservative side (in both color and style). For men, it's a very important investment to have at least one or more well-tailored suits, as on paid jobs you will often be required to bring your own wardrobe, especially for industrial videos. Bringing a variety of button-down shirts and ties is essential. Ties should not be loud (and let's leave those Three Stooges and "piano key" ties out of the picture, 'kay?)!

Women should coordinate pant and skirt suits with a variety of blouses and/or camisoles that complement eye color.

In most all cases for men and women, contemporary suits with clean lines are ideal. Avoid wide collars, pleats, awkward pockets, anything that could stick out or be unflattering to body shape.

Wool/cotton suits are often bulky and add weight to the subject on camera. Fitted/tailored suits made of thin, slimming materials are best.

Whether or not shoes will show, it's a good idea to complete the outfit with the right shoes. Think of it as method acting. Heels give some women as much a psychological lift as anything, so wear the heels. Men, heels are optional.

Wardrobe Preparation

Once the wardrobe for the shoot has been decided and gathered, it will need to be altered, cleaned, ironed, pressed, de-linted and ready to shoot. It's important that talent bring multiple options per look to the shoot so that the photographer and stylist can make any last-minute changes, substitutions, or to mix and match wardrobe. Clothes should be on non-slip hangars (invest in a good protective garment bag that accommodates hangars). This is good practice for on-camera jobs in which you may have to prep and bring your own wardrobe. Being prepared with wardrobe options really marks the professionals from the amateurs.

A few tips for good wardrobe preparation:

- All clothes must be clean, ironed/pressed, and on hangers with a fresh "off the rack" appearance

- Clothing colors should be flattering to your eyes and skin; bring "layer" options such as solid tees/camisoles, work shirts, v-necks, light sweaters etc. Patterns should be minimal (avoid bold stripes, high contrast designs, neon bright colors, and logos) and clothing should be form-fitting, not baggy or bulky

- Best pants for commercial/theatrical are denim/khakis, form-fitting (avoid baggy pants, no shorts)

- Shoes should be simple (probably will not show in photos anyway)

- Jewelry/accessories; do bring for headshots, but simple, small, not flashy; nose rings etc should be removed unless that's your "look"

- Ladies: undergarments should be smooth fitting (no lines), and not visible through garments; use nude colors

- Suits (for professional look) should be well-fitted and uniform (do not mix/match for professional look); bring shirt/tie options.

- Do bring belts (conservative for suits, stylish for other looks)

MAKEUP & STYLING

There are a few different elements and responsibilities that make up what is known as "styling."

- ▶ Hair
- ▶ Makeup
- ▶ Wardrobe
- ▶ On-set styling

Just as professional photography is key to getting images that help talent compete in professional markets, having a professional stylist is just as important, and most headshot/portfolio photographers have good working relationships with at least one or more professional stylists who do makeup, hair, and onset styling.

Some photographers offer stylist services with headshot/portfolio sessions and some may request that talent come "camera-ready," meaning fully styled with both hair and makeup. Some will offer an option of having makeup done, but no on-set styling. This is usually cheaper (but not necessarily better), as the photographer only needs to pay the stylist for the makeup

> MANY OF THE BEST STYLISTS FOR HEADSHOT/PORTFOLIO SHOOTS ARE THEMSELVES CURRENT OR FORMER MODELS OR ON-CAMERA TALENT

time. The full service would be having the makeup artist/stylist do your makeup and stay for the entire shoot to keep her eyes on how hair, makeup and wardrobe hold up through the shoot. This is ideal, because it's difficult for the photographer to keep an eye on all this while concentrating on directing the talent and getting the technical end right.

Many of the best stylists for headshot/portfolio shoots are themselves current or former models or on-camera talent, and, after years of experience, they know how to apply the right makeup for the right look. Stylists who have been in the industry and on-camera themselves are often the worker bees of these shoots, usually adept at dispensing great advice and full of insider info on agencies, photographers, and the local scene. Stylists have the ear of agencies, photographers and commercial studios who might represent or hire them, and treating a stylist badly can be very, very unwise. As in a salon, it's not a bad idea to tip your stylist if you like their work, or if they've given you some great advice and pointers on your makeup approach.

The best professional makeup artists and stylists (they're not always the same person) command top rates for commercial and film shoots, and it's hard for photographers and talent to afford them. However, many are perfectly willing to fill in the big jobs with lower-paying (but usually steady) work on portfolio and headshot sessions. For portfolio and headshot shoots, a makeup artist/stylist would typically make between $50 and $150 (or more for a full day of makeup/styling).

I CAN DO MY OWN DAMN MAKEUP

What's that you say? You can do your own makeup and hair? Maybe so—if you've had plenty of on-camera experience calling for a variety of looks in a variety of light types and have aced your makeup consistently.

Where we can all appreciate the need to save some $$, this is not an area to skimp on. If the photographer is not supplying the makeup artist, it will be up to the talent to hire a professional. Doing your own makeup is not recommended unless you are yourself a professional who's been working on camera for years and knows how to apply certain types of makeup for certain types of light and looks, compensating for how that application will read on camera. Certainly your hair needs to look the way you would make it look, at least for headshots, but a good stylist can tweak hair and knows how to maximize a cut/style for the camera.

Good makeup artists know how to do someone's makeup for the right light, using proper applications for natural light, soft or hard light, and studio light. They also consider how sheer and natural the look needs to be, and know when to "amp up" the makeup to complement the wardrobe. A good makeup artist also knows when to pull back the makeup.

The photographer should have a general knowledge of makeup application as well, if only to understand what might be required for certain looks, and to be able to review images with the makeup artist and give suggestions as to any elements that need changing. Photographers should know how to speak "makeup," to be able to direct the makeup artist.

Makeup approach is a major element of the process that separates the amateurs from the pros; men typically show up for shoots with no thought to makeup, and women often show up with too much, or have had their makeup done at retail cosmetics counters (which *can* be a great option, but usually not—these are salespeople, eager to show the product). In the world of being professional on-camera talent, you need to know makeup application, and working with professional makeup artists is the best step toward that.

Makeup should (at minimum):

- Enhance natural beauty and features
- Provide slight contouring and definition of eyes, brows, lips, cheeks
- Keep skin tones even

On-camera talent would do well to take courses on makeup for camera, or to hire a professional to do a one-time consult to go over best applications for different light, skin types and approaches; it's worth the investment to know how you can look your best, naturally. Even on commercial jobs, you may not always have the luxury of a good or experienced makeup artist, and you should know how to do your own application (guys, this includes you too—powder, concealer, bronzer!).

HAIR

For actor headshots, your hair needs to look natural, the way you might show up to an audition or job, and you need to maintain your hair with that general style so that your headshot reflects you. Many actors and models have lost jobs because they drastically changed their look (cut hair shorter, grew hair longer, colored hair differently, got a Mohawk or shaved icons into their hair) and it was not reflected in their headshot when they were hired (and they probably did not warn their agent about the change in advance, a big no-no!).

Most on-set stylists won't or can't do full hair salon treatments; typically, talent need to arrive with their hair as they normally wear it. Arriving on set with dirty, undone hair will either cause a shoot to be rescheduled or will take a lot longer to fix. Go to the salon to have your hair cut, styled and set as you like it (if you are represented by an agency, always discuss any hair changes with them). The on-set stylist will tweak and style your hair as needed based on the general style of your hair. Bring any hair accessories you might need to wear your hair a variety of ways. Always talk to your hair salon about timing; let your hair stylist know that you have a shoot, and ask how long until the cut is at it's best. Some hair has a "shocked" look a few days after the cut, and many styles need a week or so to "grow in" for their best effect.

If you have hair conditions such as thinning hair, discuss with the photographer and makeup artist. There are products that can be used to help fill out thinning patches. Some hairless spots might be easily patched in retouching.

Streaks and highlights will likely be amplified on-camera, depending on the light. I prefer talent to have more even tones that match roots as closely as possible. Frosted tips, blonde shocks and other treatments can look disastrous on camera. Proper hair color is too difficult and time-consuming to correct in post.

MAKEUP

Makeup application and treatment for the camera is very different than for everyday purposes, or for stage. A good makeup artist knows the proper approach to take for the kind of light being used (natural light indoor/outdoor, studio light, hard light, soft light) and sometimes the light source isn't determined until you're at the studio.

A really great makeup artist and stylist can transform just about anyone into something unbelievably beautiful (and Photoshop and special effects makeup can take it even further)—or, more importantly, beautifully realistic. For high fashion photography, that's a necessary art. For headshots and most model portfolio images, people need to look true to themselves, and that can be the tricky part; finding the right line between overdoing it and underdoing it. How much do you cover up and what features do you let go? Those crow's feet and "smile lines" might be as much a selling point (i.e., baby boomer, mature lifestyle marketability) as not. Be clear with your agent, the photographer and the makeup artist what needs to be preserved or enhanced.

Guys, don't glaze over or skip the makeup stuff. If you are planning to work on camera, knowing some makeup application is the name of the game. Know your colors, know the right powders for your skin tone, know your bronzers and concealers. Don't be afraid to ask your makeup artist what looks good on you and what products they recommend.

GENERAL MAKEUP TIPS & SUGGESTIONS

- Always let your makeup artist know in advance if you have any allergies or reactions to certain cosmetics, sprays, or specific products.

- Basic skin care is just good practice in life, but if you want to earn money on-camera, it's a must.

- Always bring your own lip brush and mascara; it's good, considerate hygienic practice.

- Cleanse face and eye makeup completely. Gently exfoliate skin the day before the shoot but don't get a facial or waxed eyebrow right before. These treatments can actually cause the face to break out, turn red or change the surface of the skin. All facial treatments should happen a few days before the shoot in order for your skin to recover.

- Don't sweat the zits and blemishes, they can be covered up and/or retouched. Last-minute rashes and other conditions can probably be covered up as well, just ask your makeup artist. Seek treatment for skin conditions such as acne or rosacea.

- Does your skin turn instantly red in the cold or direct sun? Does it break out in a rash from stress? Let the photographer and makeup artist know.

- Lip balm is your best friend in any climate!

- Not everyone has perfectly even skin tones on face, neck, arms and chest. Talk to your dermatologist about applications or treatments that can help even your overall skin tone. Avoid getting "tan lines."

- Know your color palette. A consultation with a professional makeup artist/stylist is a good investment to look at your color potential; she can help you determine what looks natural and flattering and what complements your eyes and skin.

- Many mineral-based makeup products can really show strong texturing on digital images. Avoid mineral makeup or any other makeup that claims to have light reflecting qualities or a "glow". These products are best left to a professional makeup artist to apply or left for personal use.

SKIN CARE

Skin is the body's largest organ, and unless you are playing a ninja or a nun, the most visible. It's your most vital asset in projecting a generally healthy look. Good skin care is also the first step to wearing makeup well.

Take those clothes off, and take a good look in the mirror (in natural light if possible). How many skin tones do you see? Every skin patch that is a different color is a potential retoucher's nightmare. You will have to watch those bikini tan lines, sunglasses "reverse raccoon" effect,

> IN ON-CAMERA WORK, YOUR SKIN IS THE COVER TO YOUR BOOK.

and the pasty white band around your wrist left by your watch. Is your chest a completely different tone than your face? Are your moles permanent or do you plan to have them removed? Any dry skin patches that need extra attention? Zoom into the mirror (up close). Where are the dry, flaky patches on your face—do you moisturize your lips enough? Did you recently have a bandage on that's left a white patch?

There are tons of websites, books and medical resources that can help you take a healthy, natural approach to skincare and offer a daily regimen you can commit to. In on-camera work, your skin is the cover to your book.

Tanning is not recommended; besides the health controversy over what tanning does to your skin, it just doesn't look good on camera. Tanning bed treatments can make you look like an Oompa Loompa, and unless you're auditioning for a tanning salon infomercial, bikini babe shoot or a documentary on bad skin, just let your skin be natural.

Keep moisturized, do a gentle exfoliation the day before the shoot (guys, that means scrub your face) and don't spend a lot of time in the sun (skin retains redness, which can be difficult to correct).

Tattoos

You should let your photographer (and your agent) know about any visible tattoos. Those tattoos you thought were so cool when you were a few years younger could certainly keep you from being cast for certain things.

ON-SET STYLING

On the set, stylists are a photographer's second pair of eyes, watching for loose hairs, wrinkles on clothing, exposed bra straps, bellybutton lint and other unflattering atrocities.

The stylist is often the makeup artist, who will be on set during the shoot to keep makeup fresh, and change it up for different looks. She might also assist the photographer by holding reflectors and diffusers.

Professional talent should make it a habit of trying on their wardrobe choices at home, in front of the mirror. Study the most flattering body positions, what movements minimize wrinkles, and whether or not an item of clothing is just too long, too bulky or baggy. A stylist has an array of clips, tape and other secret-agent paraphernalia to wrangle clothing into a more ideal fit for the talent. Some images on ads you see from the front where the model and the clothes look fabulous, if seen from behind, look more like a Tim Burton nightmare. If talent does their work beforehand and comes prepared with good-fitting, clean clothes, it reduces a lot of on-set tweaking. Be aware of undergarment lines and colors that show through and make sure you have appropriate options for the shoot.

GLASSES

If you wear glasses and need them to see (and would be wearing them on set for any job) then you need images with you in your glasses. If you wear contacts and glasses but can work in just contacts, then you don't need to shoot with glasses on. Some photographers prefer to "pop out" the lenses of glasses to eliminate glare, but I don't do this—it turns the glass frames into props; just position the subject and lighting properly and take any little glares out in post retouching.

THE TEETH, THE WHOLE TEETH, AND NOTHING BUT THE TEETH

Next to skin care and eye care, teeth are pretty darned important to the on-camera professional. Adults with bad teeth should be doing whatever you can to get them straightened, crowns and fillings replaced, or any work that's needed to give you that confident smile.

Children who are about to lose teeth should check with their agencies as to whether or not they should shoot or wait until teeth are back in. There are teeth props called "flippers" that can be provided by dental specialists; these can help kids (or barroom brawlers) by providing a plug where a tooth should be (and hopefully will be again).

If you have a gap between your front teeth (didn't hinder David Letterman, right?) and are not planning to have it fixed, you should show it as is. Bad teeth can sometimes be readjusted or corrected in retouching, but you will need to have them fixed. Or, do nothing and wait for them to start casting the sequel to "Deliverance."

The most common problem, however, is yellow teeth. If your teeth are yellow (and you can definitely tell in pictures), you should be on a teeth-whitening regimen using the whitening "strips" available over-the-counter, or consult your dentist on best practices for keeping the teeth and gums healthy and correctly colored. Over-bleached teeth look surreal and fake. It's expected to take some amount of yellowness out in the retouching phase, but you shouldn't rely on this.

Natural teeth are not white. They're really more of a grayish hue, an off-white. Making teeth perfectly white and bright is usually more creepy. Again, keep it real!

Em"Brace" the Braces

Kids or adults, if you're in braces, there's no hiding it. Either wait until braces come off, or embrace the metal. If it's time for new headshots and you're within months of getting braces off, consider waiting. If not, the photographer should be taking pictures with your mouth open and closed. You will have to overcome any awkwardness you project with braces. Some orthodontists will consent to removing braces for a shoot or important event; this might be an ordeal or a breeze and only they know, so consult them.

PERSONAL PREPARATION

If you're going to your headshot session (or even to an audition or on-camera job), this is the least that you should do to prepare yourself in terms of cleanliness and hygiene. If you will have a professional makeup artist, this will certainly help her, but most importantly, you will make a much better, more professional impression.

- Clean face and shampooed hair, styled naturally (or styled as requested by stylist/photographer)
- Dry/flaky skin exfoliated
- Eyebrows maintained
- Face/skin moisturized
- Eyes clear (use eyedrops to get out redness)
- Stray hairs plucked (men, you'll need to know if you should have beard growth or be clean shaven)—don't forget nose and ears!
- Jewelry removed so skin lines and impressions are removed; don't wear tight clothes that will leave red marks and impressions on skin (especially if you are showing any skin on camera!)
- Fingernails clean and manicured (clear polish, no tips)
- Teeth brushed and flossed and whitened

THE SHOOT

Now that all the preshoot preparation is done, you've hauled all your clothes up to the studio, you've sat in makeup and prayed to the magic photo fairies to give you a great shoot, it's time to get on camera and act perfectly natural, as if you've just been caught in a moment. How hard can that be?

LOCATIONS AND BACKGROUNDS

Different types of headshots are best served with different backgrounds. Most importantly, no type of headshot or promotional image should ever have a "portrait" feel, so I always avoid muslin backdrops, cloth backdrops, and any type of constructed "set." Bonus hint: no trees.

ENVIRONMENTAL BACKGROUNDS

Given the typical headshot backdrop locations, you'd think that the vast majority of actors and models hang out in grungy alleys, chipped-brick lofts and parking garages. Maybe some do. You'd think that models are constantly crossing the street and laughing at things happening off camera. But nondescript alleys and long neutral-colored walls make great locations because they offer some location ambience while providing perspectives that can be "blown out" (dropped out of focus) to keep the sharp focus on the talent. For some, it provides an "edgy" locale that fits their personality too. Backgrounds should not be obtrusive or busy, too bright or too dark. An "on-the-street" look is great, provided you don't have power lines and stoplights running through your talent's head.

These kinds of locations are often chosen simply because they are the spaces around a photographer's studio or apartment and are public thoroughfares where permission isn't required. Locations don't need to be cool places, beautiful buildings, or even studios. I've shot in garages, hallways, alleys, wherever the light is best at the moment. I have done some amazing headshot images in car washes. Places like these have a way of "funneling" light so that you can achieve a nice ambient back light from one end, while getting a more diffuse, flattering natural light on the front end.

One thing an outdoor location does is provide, purposefully or not, some kind of subtext or context to an image. A shot with an alley background is going to be, at least subconsciously, perceived as grittier or more dramatic than a shot against a studio white backdrop. If used with some subtlety, this can work well if the actor wants to convey a certain "type."

However, never let the location be the focus. This is a huge problem with portrait photography—when I see pictures of a person or a family sitting in a park surrounded by trees, I can't help but think how the photographer has lost sight of the subject and might as well be taking landscape shots. This can easily happen with headshots and model shots as well. I have seen many a headshot or portfolio shot that is lush and beautiful, sharply processed, with oodles of brilliant lustrous light and angelic sheen, it's absolutely beautiful and professionally styled and you just want to melt into the pictures! These may be magazine-worthy images, but they're selling the photographer—not the talent.

The bottom line when shooting within a certain environment is that the talent must be the focus. The background cannot overwhelm the subject. Looking at the grids of talent headshots on agency websites, the eye is usually drawn to those images which are brighter and frame the subject clearly and cleanly.

IN-STUDIO BACKGROUNDS

My own studio is decidedly low-key. I do not invest in tons of different lighting setups, colored backdrops, pre-built sets or other studio props. I use one set of studio lights (Elinchrome) and utilize a variety of white seamless backs, foamcore sheets (used as fill and backs), reflectors, sheer drapes to soften hard light coming through a door or window, and I rely heavily on the big windows in the front of the studio to provide the best natural light. I keep things very simple; I'm usually a 1-light photographer, be it studio strobe, Speedlight, or monolight. Actor headshots need to look natural. The more time I have to spend fussing with lighting setups, the less time I'm concentrating on the talent.

CYC WALL/WHITE SEAMLESS

You can't beat the simplicity of a classic in-studio solid white back; it pushes all the focus onto the subject and strips the image of any environmental subtext or context. I like to temper the shades of whites/grays depending on whether the headshot needs to be more dramatic (theatrical) or cheerfully bright (musical theatre). A white or gray backdrop is also ideal for most websight usage, as it's uncluttered and can mesh better with webpage designs.

I would rarely use a colored background, as it smacks of portrait setups; it might be OK for young children. Black backgrounds lend themselves too easily to the portrait-style "Rembrandt" look and are just too dark and dramatic and artsy for good general headshots, but can be striking and dramatic for film/theatrical or models headshots. However, letting backgrounds fall into dark tones can achieve the effect of underscoring theatricality, moodiness and can provide the right context for certain looks.

It's a good idea to check with the agencies to see if they have preferences; as all their talent are usually listed together, they may not like jarringly bright backgrounds on some of their talent, mixed in with others.

LIGHT

The best light for headshots is a clean, diffuse natural light which is flattering to most skin types. This is most often best achieved under overcast skies—let the clouds do the work for you! If it's a bright sunny day, you will want to be sure to have a diffuser with you, at least large enough to cover the body from the direct hard light. Sometimes even clamping curtain shears between two light stands can serve nicely. It's always a good idea to have your standard gold/silver reflectors and white panel diffusers with you; however, you can achieve reflection or "bounce" light from a number of objects that might be around; a colored wall, a car hood, the side of a truck—test the light on the subject and see how it reads.

Often, I get the best in-studio results by putting talent in front of a large window (which I cover with diffusing material) in a position where I get a little natural backlight (i.e., a window in the back of the studio or a white/gray wall). Of course, times of day produce different light quality and intensity, and you'll need to be familiar with how your space and light change throughout the day and compensate for it. Working primarily in the Midwest or anywhere with drastic climate change, it's a must to have an interior space option since outdoor temperatures can swing uncomfortably from season to season.

GETTING THE "ENERGY"

What is this "energy" we keep talking about? It's not just as simple as a smile, and not as complicated as quantum physics. Does that help nail it down? I hope you get the point—good energy just is. It's a delight to photograph someone who really wants to be in front of the camera. The ability to focus your energy and offer a variety of expression is gold when it

> IF IT LOOKS LIKE YOU'RE TRYING TOO HARD, YOU PROBABLY ARE

comes to on-camera performance. It's usually something that just comes natural. If it looks like you're trying too hard, you probably are, and if that's the case, you'll need to practice breaking down any subconscious barriers that are keeping you from acting naturally in front of the camera the way you act throughout the rest of the day.

For talent, it's good practice to consider your time in front of the camera as if you are performing professionally—of course, the role you're playing is *you*. The "set" may be that location alley, or very unglamorous garage, but hey—you're an actor. Once you are on "set," it's time to perform, energize and deliver.

There are things the photographer and studio can provide, however, that keep energy up and help the talent perform more confidently.

Setting the Mood

We like to be prepared for anything at our studio—music preferences, quick energy fixes, fashion and talent magazines and media to refer to, cold and hot beverages, a couch to crash on if needed, a full changing area and comfortable washroom, even a working shower.

We keep nuts, granola bars, yogurt, soda, juices, tea, coffee and a variety of snacks and drinks to keep everyone hydrated and energized; sometimes downing that energy drink makes all the difference in the world for on-camera energy.

It makes sense to set the mood with music; I keep an MP3 player full of a wide variety of thousands of songs in every genre connected to the studio stereo; I have a remote for the player so I can quickly change song, artist or genre without skipping a beat during the shoot. I also ask talent to bring their own player or CDs that make them feel great and energetic. Having a satellite radio subscription is also a good idea. Music sets a mood, so use it.

Comfort levels

Most working actors and models are fairly tough and can work through any conditions.

Outdoor locations in extreme heat or cold can be miserable and should be avoided because it's hard to project natural energy when your body is screaming for relief. Photographers need indoor and outdoor options. I've pushed it with talent before in these conditions, because I'm a tough director—but really, the less distraction the better.

The Crowded Set

Most photographers rightly prefer to keep the people on set to a minimum; usually that means a stylist and talent. Unless someone really needs the security and moral support of a friend, spouse or relative (if you are over 16 and need this, you should really question your ability to work on-camera), studio visitors or "chauffeurs" should drop off the talent and hang in the lounge, or a nearby café. Parents of smaller children are always welcome, provided they are out of the way. The big no-nos are anyone standing behind the photographer glancing at images, making comments, chatting or trying to direct the talent themselves. If small kids are on-camera, they should be adept at taking directions and feeling comfortable in the studio or location environment without their parents (because parents are rarely allowed on commercial shoots).

Children

With smaller children, usually ages 4 to 7 or 8, we like to let them explore a little, chat with them before pulling the camera out, and get any little fears or curiosities out of the way. Headshots and portfolio images of children are usually full of high-energy, great smiles and sometimes a sense of action or play. I will almost never "talk down" to a child. Since many children are having their first professional on-camera experience with us, we give them direction, let them know what to expect and what we expect of them, and see how they respond to directions and what their natural energy is. Agencies (and parents) want to know your honest assessment of a child's energy and demeanor on set. It becomes pretty obvious if a child is uncomfortable in front of the camera or just has no interest in the experience. Photographers should be really frank about this with parents and agencies. It's also important to pass on the behavior of certain parents who can't stop directing from behind your shoulder, or who can't let go. Parents need to know the importance of letting their little one perform solo; they'll have to if they're going professional.

Talent – look in the mirror!

You've probably scrutinized your face and body enough to know what your flaws are. You can tell the photographer and the makeup artist: "I have a lazy left eye," "my right side is my best side," "hard light really emphasizes this little scar I have." Pros will see these issues for themselves and will try to work with you on the most flattering angles. But most issues ("I'm bloated today," "do I look fat in this?") should be left at your home door; stop worrying, let them do their job and trust that you'll come off flattering.

FRAMING THE SHOT

GETTING FRAMED

If you look at a headshot or portfolio image and you see the picture before you see the person, then it doesn't work.

The photography can't steal the show; the image itself shouldn't be more dynamic and attention-grabbing than the talent. This is a huge problem if you're shooting an actor (or

> THE PHOTOGRAPHY CAN'T
> STEAL THE SHOW

executive!) who is dull and dead-eyed; that's why an ability to direct someone for expression is a must. If, in the end, the talent just doesn't deliver, then they have some very nice pictures of themselves that capture the "blah" they project.

You must achieve good natural smiles for commercial shots, and some general dramatic focus for theatrical shots. There are other elements to focus on, however, if appropriate--the quirks, the selling features, the character inherent in some actors' faces can be quite unique—do they have a particular quirky feature that needs to be focused on? Is their smile absolutely golden? Does their arched eyebrow have a commanding energy? Are their eyes unusual, exotic? If there's something unique about their physical appearance, get some shots that focus on that.

Photographers: It's easy to get carried away with artistic angles, upshots and creative focusing; just remember that if you're shooting for headshots or comp cards or other printed marketing materials, those images need to be clear and well within the "portrait" or "landscape" format that can fit on printed media.

There are a couple of phrases for shots that are perfectly centered with the subject directly facing the camera: "driver's license photo" and "mugshot." Angles are best for most people; find the flattering angles and shoot them. It's usually best that you shoot around eye-level, so as to have a realistic representation of what they'd look like in the casting director's plane of view.

If, however, you're shooting candids (unstyled mugshots for agencies) you should be sure to show complete body and complete head as well as left and right profiles. Some agencies have very strict guidelines for candids; you'll need to inquire per agency.

Landscape vs. Portrait Mode

Most headshots and portfolio images need to be in portrait mode (longest side is vertical) for practical purposes; so they can be maximized on an 8x10 reproduction or 5x8 comp card, or fit within a website template formatting. However, more and more brave souls are breaking out of the box and realizing that landscape-mode shots (longest side is horizontal) can be striking, even more "cinematic" than the standard. Even though a landscape-mode shot would reproduce smaller on a vertical 8x10 reproduction, it can make as great an impression. Or, they can be reproduced full frame on landscape mode (10x8) paper. See "Landscape vs. Portrait Modes" on pg. 128.

The Right Angles

Headshots are usually pretty direct; casting folks like to see the actors as if they are standing before them. Angles are flattering, but using creative up/down angles can look cool but skew perspective. It took me a long time to learn this; I would throw some interesting, artsy angles into proofs because I thought they looked great, but they would never be chosen as "the shot." If you can't stand the straight-on mundanity, shoot the creative angles for yourself and leave them off the proofs.

For general commercial and theatrical headshots and most promotional images, the talent's eyes and face need to be the first thing that catches the viewer's attention, and you should provide choices from a variety of points around your subject's face (talent may let you know they have a "good" side, but let the camera be the judge). Some people will subconsciously offer only their best side, and are uncomfortable showing the other side, but I remind them that the shots are digital and anything that doesn't look flattering gets zapped, never to see the light of day. If you're taking and saving embarrassing pictures of them to hold onto until they become big and famous, do the courtesy of letting them know.

Cleavage Control

The first thing you want casting directors to focus on are the eyes—not the "girls." Hike up the tops, secure the bras and straps, and keep crops and angles "clean." If you're shooting promotional models (girls who are hired as eye candy), or body shots, of course body form is important to convey; but there is no need to cross any line into outright sexy or salacious imagery.

Options and Variety within each Look

"Looks" are defined generally as distinct setups with wardrobe styling, background, light differentiation and hair/makeup type. A photographer should shoot varieties within each setup or "look." Shoot with/without a jacket; with/without a tie. Change a top/shirt. Do variations on

hair styling. Definitely run through varieties of expression in every look. Shoot close-ups, waist up, three quarter and full body shots within each look, if appropriate.

Photographers: take the concept of "bracketing" (where you would under- and over-expose each shot to get varieties of exposure quality) and apply it to styling and expression within each "look."

SESSION LENGTHS

So how long does it take to get "the shot?"

Of course it varies from shoot to shoot. I never limit a shoot, even a 1-look shoot, nor is there a need to stretch one out to an all-day session. People's energy levels crest and crash, and it absolutely affects the quality of the images. I've had talent nail great looks within minutes, and sometimes it takes several jump-starts and changeups to get good images. There is no rule. If the planning and styling and clothes and makeup are all good, and you're not getting good images within a couple hours of the shoot start, I'd say wrap it and reapproach with fresh energy at a different time. Sometimes talent will take some time to wake up and energize. If I find myself taking the same shot over and over, I change things up completely. A good headshot shoot for general commercial and/or theatrical headshots shouldn't really take more than 2-3 hours including hair/makeup time. A multi-look portfolio shoot, however, can easily be an all-day affair with makeup and location changes.

It is the talent's job to bring the energy and the photographer's job to direct it; if talent just isn't delivering, and a reschedule needs to happen, it should count as a completely new session. Part of the vital collaboration is for the talent to be "performance ready." No amount of photography skills or directing skills can pull charisma out of a dead turnip. No amount of excuses ("I'm going through a breakup," "My dog ate my personality") are valid for showing up at a shoot with zero energy.

DIRECTING FOR EXPRESSION

For actor headshots, there are two key expressions an actor needs to nail: a good natural smile and a more dramatic energy or intense expression. This will give you good options for both comedy and drama. With any headshot look, you need to be as focused on the lens as it is on you. For most other talent needing a professional image, such as business professionals, authors or politicians, they need to convey warmth, confidence and perhaps some kind of authority. Most people automatically become self-conscious when a camera is trained on them, and it usually takes some good direction to bring them back around to a natural, sincere range of expressions that reflect their personality.

Some talent are keenly aware of the energy they project on stage or on a film/video set with other actors to interact with. They are thinking about it, inhabiting it, and working to put it out there in a big and noticeable way. The same actor, when speaking with somebody one on one, may be less aware of the energy they project personally. Talent, ask your friends how you come across in person compared to how you come across when working the stage or on a set. For a headshot shoot that is confined to the intimacy of a single talent and a single camera, you have to inhabit *you* and project that in a more intimate setting. Photographers may not know you personally, but they should know what isn't reading authentically.

> YOU HAVE TO REMIND YOURSELF THAT YOU DO THIS VERY NATURALLY ALL DAY LONG

One of the first things that can trip people up is coordinating their facial expressions with their body language. As an on-camera talent, you have to remind yourself that you do this very naturally all day long, but for many, a wall comes up when that camera focuses on you, and suddenly you feel like a stringless puppet, unable to move without specific direction. Do what comes natural. Engage with the camera as if it's a good friend, laughing, joking, and listening intently. Flirt with the camera (not the photographer). You are having a dialogue with the lens; you're telling the camera something important, you're just not vocalizing it.

Look at expressions in headshots, advertisements and editorial pieces that reflect your demographic. If you have an agent, have them show you samples of headshots in your demographic that have gotten jobs for their talent.

Try out expressions to see how they read. When told to look angry and intense, some people will read "interested." When given a direction to look sincerely happy, some might read "curious." The human face is capable of making over 7,000 distinct expressions. Most agents and casting directors want to see those magic two: naturally happy smile and dramatic focus.

DIRECTING FOR EXPRESSION

If the talent just isn't delivering a range of expression—and this is, unfortunately, more common than not—try to redirect their attention by engaging in some banter. I usually get them talking about what kinds of roles they'd ultimately like to be known for, and what they might consider

> THE HUMAN FACE IS CAPABLE OF MAKING OVER 7,000 DISTINCT EXPRESSIONS.

a real stretch. Having them emulate some of their acting idols' best roles might produce results. Most people have a "comfort zone" in which their range of expression resides; I like to push them out of that zone just to see how they read. Sometimes, horrible. Sometimes, hilarious. Trying to get someone who is all smiles to shoot laser beams through the lens can be a challenge. Trying to get that macho guy to crack a great smile is equally challenging; but it is often worth the exercise. Quirks come out; weaknesses get exposed.

Here's an exercise we practice at Limelight Studio: memorize a poem, a song lyric, a brief monologue that—when read aloud or acted out—elicits a variety of facial expressiveness. When on camera, run through the dialogue in your head, without mouthing it. Let your face express, but don't vocalize the words. Practice this in the mirror with different takes.

Here are some other "motivation/emotion" triggers that have produced results at our studio; you could literally put each of these on little slips of paper and have the talent pull one out of a hat—no two people will read alike when performing these suggestions (some will interpret these brilliantly, and some will produce awful results!):

- ▶ Flirt with the lens
- ▶ Look as if you're really glad to see an old friend
- ▶ Shoot laser beams from your eyes into the lens
- ▶ Close eyes; do a 3-count, on 3, open your eyes and burn a hole through the lens
- ▶ Look like you've got a secret or have just gotten away with something
- ▶ Arch an eyebrow (maybe 1 in 20 can arch just one)
- ▶ Look pissed
- ▶ Look bitchy
- ▶ Look cocky
- ▶ Look surprised
- ▶ Act like you're delivering a monologue, but silently

The key with these "motivations" is that when talent tries to convey one, it may well read like something else entirely. The motivating suggestion is basically a trick to get an expressive result. Run through exercises like this to nail expressions that look valid, intense, and/or honest. Zap anything that does not have good eye energy.

Talent: are there expressions that define you, capture you, or characterize you? Is it a golden smile, a quirky cock of the eyebrow? Ask your friends and family and fellow cast members. If you have a trademark quirk or expression, own it—and project it for the camera.

"Owning the Lens"

I honestly don't know if I made up this term or heard it somewhere and just started using it. But it's a great description for the kind of confidence talent must bring to the camera. We project

OWN THE LENS; OWN THE MOMENT;
OWN YOUR IMAGE.

a slightly different energy when we have some power over another and need to tacitly convey it. Own the lens; own the moment; own your image.

Nailing the smile

Taken literally, this would hurt a lot. Kidding aside, it would seem all too easy to smile for the camera, right? In fact, for many, it's torture. I get the best, most natural smiles when the talent is actually laughing or chuckling, rather than trying to smile. Talent, have your own private joke ready and be prepared to yuk it up on camera. Photographers, watch diligently for fake smiles and any expression that doesn't read sincere. Some people have a great natural smile and can turn it on instantly; for most, it actually takes some work to get there. Don't smile—laugh!

I'm Too Sexy for this Shoot

Sexy is not an expression. You either "are" sexy or you are not. It's a naturally expressed energy, and any forcing of it through vamping on-camera, fan-blowing of hair or other tricks, will not create sexiness where it does not already exist. Sexy just is. Confidence reads sexy. Natural humor reads sexy. Anything else is trying.

Where do you hold your tension?

Everyone holds tension in their face and body, and it is usually most prominently noticed in times of nervousness and stress (which, for some, will be the photo shoot). On some, it's a vein that bulges from the forehead or temple, lips pursing, tongue pressing into the teeth. Often, it's a tension around the mouth. For others, it's the neck muscles or shoulders. For yet others, it means hives and projectile vomiting. A good photographer can usually spot the

tension points within just a few images, and you should have some relaxation technique handy that can help you feel more relaxed.

We've actually had people hold their breath when shooting. As this kind of tension can kill you, we really encourage the talent to continue all natural body processes—particularly those that sustain life.

BODY LANGUAGE

One of the biggest hang-ups for any kind of talent is to match facial expression with body language. Again, it's something we do naturally all day long, but once the camera's focused on you, self-awareness can play tricks on your natural demeanor.

Here's a vital tip: forget that the camera is looking at you. You should act like *you* are looking at the *camera*, focusing on it, interested in it, intensely listening to it.

Use general common sense with body language and positions. For actor headshots, arms crossed, hanging over the head or stretched out aren't always conducive to a relaxed and natural image. The subject should stand naturally, the way they might stand if they were just having a casual conversation with someone. There might need to be tweaks to this stance and positioning, for instance, to get a little separation between an arm and the body to show better body form.

For lifestyle shots, you're trying to catch someone "in the moment," and the subject is usually looking at or engaging with someone or something off camera and not looking directly at the lens. You can get more creative with lifestyle shots depending on the setting, but remember you will need to show expression and body, so keep things open.

For corporate and professional looks, I tell the subject to imagine themselves as if they're greeting an important client at the moment when they're stepping forward to shake a hand or express how pleased they are to be meeting. The expression should be one of confidence and openness, ready to engage in conversation and negotiation.

People as Props

If you're doing lifestyle images for someone's portfolio that involve multiple people on camera, never lose focus of the subject (the person whose image you're selling). Photographers should use lenses that can handle a proper depth of field that slightly "blow out" or drop focus on other people around the main actor or model. Or you could position the secondary person lower than, or somewhat in the background of the primary talent.

Multiple subject pictures also run the risk of having one person upstage the main subject. Children, dogs, and extremely attractive women or men (who are more attractive than the subject) are going to pull focus away from the subject. If the model or actor has weak energy, they'll be swamped. Use "people as props" wisely.

Fashion Sense

For fashion portfolio images, the body language and facial expressions need to complement the type of look you're shooting for. Classic, more iconic model "poses" such as hands on hips, shoulders rolled forward, and joints bent in funky poses are more for fashion looks. If you have a high-fashion model competing in a national fashion market, go for the model stuff. It's all about their body expression and how they wear the clothes. Get creative.

Trying to shoot "high fashion" images or images that mimic the high fashion looks of national fashion magazines isn't recommended unless a) you're shooting high-fashion models who are the right body type, and b) those models are working or submitting images to high-fashion markets (New York, Paris etc). "High Fashion" images are those that are shot by top photographers and models for national ad campaigns or editorial spreads in leading and on-the-edge fashion magazines. Topping that list would be publications such as *W*, *Glamour*, *The New York Times Magazine* fashion spreads, *Elle*, *Vanity Fair*, and countless others. If you are not shooting for these markets or a talent's submission to these markets, these kinds of shots aren't likely to help market them in their individual portfolios—unless they get a job involving high fashion and are able to use the tearsheet of that ad or spread. Then, it's a huge plus.

REVIEWING THE SHOOT

If you've done all the right prep work, brought the right clothes, had good styling and nailed some great expressions, then once the actual shoot is over you should have a lot of good images to choose from. There may be hundreds of shots to review and many of those will be deleted for technical reasons, redundancy, or poor energy (although personally, I like to keep some bloopers such as monkey yawns, half-eyed drunk looks, or Nolte-ish mugshots). In most shoots, you're really trying to achieve one to five great shots for use as printed headshots, comp card or portfolio or internet images. Those are the shots where the talent was right on, the photography was right on, the clothes were flattering, the energy was just right, the light was just right and everything came together for a "wow" shot. A handful out of 100 may be right on. If you have lots of other "great" images to choose from, that's pure gravy.

I always like to review images with talent, either in-camera or on computer before the talent leaves the studio. The digital world has made this instant review possible, and it saves a lot of headaches and anxiety. I want the talent to feel good about their images, and don't want them coming back later asking for reshoots. If anything needs to be changed with styling, makeup, or their overall energy, we make those adjustments as we shoot, but the final review is their opportunity to assess the shoot's success.

The talent need to know that the photographer has brought out their best, reflected them naturally, and created solid, marketable images. The photographer needs to know the talent is happy with their images and writes that check. I always get a smug sense of satisfaction when talent leaves my studio with a girlish squeal of delight; especially the men.

WORKING WITH AGENCIES

How cool does it sound to say "I have an agent," or "Excuse me, but I have to take this call—it's my agent." Then how cool is it to say, "Excuse me, but I have to go spend some bucks to provide my agent with the right tools they need to market me!"

Once an actor, model or spokesperson signs with a talent agency, that agent will require them to have professional headshots and images taken. These are the most important tools the agencies need to market their talent, and the most important investment the talent makes in their own career. Many agencies, no matter how small or where they are located, are keenly aware that, via the internet, they are working on a global stage. If they are aggressive about pursuing work for their talent in multiple markets, they need images that compete with the best promotional work done coast-to-coast or run the risk of looking "small town."

Photographers and talent both need to be familiar with the top agencies in their market and region. Some agencies handle all talent (print/runway, broadcast/film/TV/theatrical) and some might specialize (runway only, or promotional models only). Agencies are a key source of business for the photographer, and the guiding hand for the talent.

I try to maintain good relations with all agencies in the market and am keenly aware that the agencies compete with each other, so I am very careful not to speak of other agencies or inadvertently let any information slip about a competing agency (if I am privy to such information, which often happens when you have a good working relationship). Agencies will usually work with a variety of photographers as well, and some agencies like to have close

> THE AGENT, TALENT AND PHOTOGRAPHER RELATIONSHIP CAN BE TRIANGULATION ON STEROIDS.

relationships with the photographers they recommend; mostly, they need to feel confident that when they're asking their talent to spend hundreds of dollars on a shoot, prints and comp cards, the photographer is going to give them what they need and provide a consistent level of follow-through, proofing, retouching and service to rely on. The agent, talent and photographer relationship can be triangulation on steroids; a love-fest when all are on the same page, but potentially explosive if differences and egos clash.

It's sometimes easy in the "triangle" for the photographer to get stuck in the middle, between the agent and their talent. Most talent defer to their agents on shot selection, cropping, even retouching specifics—but some have a problem reconciling their own self-image with their realistic market potential. If you interface with an agent over a talent's image more than the

talent themselves, it's easy to forget that the talent is still your primary client (they're the ones paying you!). It's not uncommon that an agency wants to market the talent in a certain direction (i.e., lifestyle) but the talent sees themselves differently (i.e, high fashion). Or an actor wants to do serious and dramatic film roles, yet the agency really needs big smiley commercial

> YOU WILL BE DEALING WITH EGO VS. MARKETABILITY, OTHERWISE KNOWN AS PERCEPTION VS. REALITY.

shots on them. As a photographer who needs to capture the images the agency can use and still make your talent client happy about themselves, you will be dealing with ego vs. marketability, otherwise known as perception vs. reality. Sometimes you are the bridge and just need to get images that both work for the market and appease the ego, if necessary. The smart photographer will shoot the variety and give multiple options.

Some agents like to know a photographer's opinion of talent they photograph, especially for talent just starting out; were they good on camera, did they take direction well? This can be important because the agent needs to know how the talent "performs" on camera; if the talent's on-camera energy is dead, or if they have a diva attitude, or came completely unprepared, that does not bode well for their job potential. Talent need to treat their headshot and portfolio shoots as a professional experience. Likewise, talent will be full of praise and criticism for the photographer and stylist, and agents will constantly be assessing a photographer's performance based on talent feedback, and of course the images themselves.

I have made it a practice to try to meet with agencies at least once a year to do an overall review of how they like my shoots, things they're tired of seeing, new trends in styles and images from other markets, and their preferences. They appreciate the communication and know that their opinions are heard and acted upon. Even though they're (usually) not paying the photographer, you should treat them like an important client because they're sending the business to you.

Photographers Seeking to Work with Agencies

Photographers first need to study the agency's website and see the general style and quality of the images on their talent—and assess whether the quality of their work is up to par or superior. Agencies are usually happy to meet with new photographers and review their work, or review an online portfolio. You would make an appointment with the head of the agency or the bookers themselves. Making a good impression is all about the quality of your work and also if your pricing is within the general range of the market (do not underprice yourself; undercutting other professionals in order to "steal" some business will likely come back to bite you later as well). You can offer to test (see below) for free or at a reduced rate, but when you have competitive quality work, set your prices according to the area's market.

It's important to bear in mind that, when trying to impress an agency that you're the right photographer to work with their talent, you're not trying to sell them on what a spectacularly creative and kick-ass photographer you are; they need to see in your portfolio that you "get" people, that your images can market a person's style, character, and energy. It's not about backgrounds or creativity; it's about the subject, the image—and your professionalism.

Testing

"Testing" can mean a few different things; if you are a photographer looking to build your book and get into the headshot and portfolio business, you might offer shoots for free, but you'd still need to show a quality level of work for the agency to feel comfortable sending talent your way, even for a free test.

"Testing" can also refer to new talent doing a first-time shoot and "testing" their on-camera ability and looks with a professional photographer and stylist. This is most typical with print and lifestyle models.

Variety

When you are dealing with agencies, they are going to see your images on a daily basis; I'm also sometimes turning in 3 to 5 shoots or more per week (per agency) for their review. I'm keenly aware when shooting that I have to change up backgrounds between shoots, rotate environments and colors, and make sure I'm not being too redundant. After a while, they see the same old look or background and start wondering if there are photographers with a fresh take.

That said, there are certainly very successful headshot photographers who have a very defined and consistent look, such as a certain studio light quality on white background. If you perfect a look that works and sells, run with it and make it your trademark look!

Talent Seeking Agency Representation

All actors and models want an agent, right? This isn't a book on how to get an agency contract (there's plenty of info online about the best methods for auditioning and general agency requirements), but when it comes to the photographer/talent relationship, talent seeking agency representation often make a first stop at the photographer's studio. If you're a photographer who shoots a lot of agency talent, your advice to beginners can be an important first step. Of course, that important first step for the talent is to get professional images—but agencies do not usually require professional images to sign new talent. They can review candid 5x7s showing good smiles, full body and good energy. Some agencies are content to review images online. I am always careful to let talent know that a professional shoot is not a requirement by agencies for submission purposes, especially for print models.

However, I've seen professional images make a difference in an agent's opinion of whether or not to sign talent. It certainly lets them know you mean business and have taken the first professional step, and lets them see you more professionally. If you shoot images prior to being signed by an agency, it would be a good idea to hold onto the proofs or make sure your photographer can make available all images from your headshot session so the agency can review and make any alternate headshot decisions once signing the talent.

> I'VE SEEN PROFESSIONAL IMAGES MAKE A DIFFERENCE IN AN AGENT'S OPINION OF WHETHER OR NOT TO SIGN TALENT.

Talent do sometimes switch agencies, for a variety of reasons. Should you use the same images you'd been using at your previous agency? There is no rule, and copyright to the images is still held by the photographer, so that should not be a problem. However, most agencies prefer to have their own identity, and since agencies within the same market and region often serve the same commercial clients and studios, they will likely want fresh images more identifiable with their agency's marketing strategy. They may not want to submit images of you that were previously submitted by a rival agency. This is something to bear in mind when contemplating an agency switch; a whole new investment in headshot and/or portfolio images.

AGENCY "PACKAGES" AND "SCHOOLS"

I always caution talent about any institution that tries to sell them "packages" of their own in-house photography, or headshot or modeling workshops. Talent experience varies with these "schools", so use your best judgment when confronted with an agent trying to sell you packages. Most agencies do not make their money on selling headshots to their talent; they may have a list of preferred photographers, who they know are professional and deliver consistently good images that sell their talent. They may also recommend and facilitate events with local workshops or acting coaches; but they do not sell "packages" including in-house photography. If you are still tempted to be listed with a "school," then compare their headshot quality (and pricing) to other local headshot photographers, and see who does the most professional work.

WORKING WITH INDEPENDENT TALENT

Developing Talent

If a photographer shoots a lot of talent and works with a variety of agencies, they will at some point be in a position to make recommendations and send people to agencies. This does not make the photographer a "scout," (someone who works for an agency and specifically watches out for potential new faces and talent). It's important for talent to note, however, that a photographer's opinion is just that—an opinion, and it may or may not hold much weight with an agency depending on the photographer's working relationship with that agency and their level of experience within the industry.

Photographers, if you have a good eye for potential talent or print models, agents can appreciate your sending talent their way. However, having an "in" with an agency doesn't mean you should be sending all your pretty nieces and friends their way. Be discerning; if you're shooting with talent who are trying to break into the market, be realistic and only personally recommend those actors or models you feel are really worth "crossing the velvet rope." Having a good eye for potential breakthrough talent usually takes a keen knowledge of the industry, and a great deal of integrity.

Talent should always be wary of any photographer who also claims to be an agent. Photographers who are well-connected and established, or work with studios who do work for professional business or advertising clients, can certainly get talent jobs of a certain kind, or hire them for certain work; but the claim to be an "agent" should always be treated suspiciously. If you come across a photographer whose work is good, and they claim they could represent you for work, ask to see their client list and talk to other talent who they represent. Of course there are exceptions, and there may be genuinely talented photographers on staff at good agencies. In general, strong discretion is urged in dealing with those claiming to be both agent and photographer.

Unsigned Talent

There's a lot of great talent out there who are not or do not want to be represented by professional agencies, for a variety of reasons. They may work primarily in stage and theatre (most talent agencies outside of NY and LA do not represent stage talent), or they are savvy enough in marketing themselves that they do not need representation.

Some have worked with agencies in the past, and know very well the market they're in and what types of looks they need to promote themselves with. Others may be perfectly talented and/or beautiful, but just did not fit into the agency's mix.

Then, you have the good folks who just don't have the talent (you don't necessarily know who you are). A photographer's level of experience in the industry (and overall people skills) can best gauge what level of honesty they are compelled to share with these people, and how constructive they can be. The job of most photographers is to deliver great marketable pictures and make sure the talent looks good. You can be constructive in your advice regarding the energy level they bring to your shoot, or their preparedness or lack thereof, but you can't really judge whether they will ever have a career or a shot at their dream. Provide them with what they need (even if it's just a good round of images for their own self-esteem) and let the market figure the rest out. When working with people I suspect won't get far in acting or modeling, I usually make the focus all about them and try to get images that will make them feel good regardless of whether they will ever get work. Sometimes, people ask my opinion—especially parents who wonder if their child is right for this kind of work. I'll offer it honestly and constructively.

CHOOSING "THE SHOT"

This is often the part where the photographer bows out; some agencies and/or talent appreciate knowing what your top picks are—after all, you shot them and witnessed the energy and circumstances that made that shot happen (out of hundreds you may have shot); and you know how much of the result was their natural energy or your pulling it out of them after countless tries. But the final pick goes to the agent and/or talent.

If I'm working with an agent or talent who wants to know my opinion, I usually pick two or three images from the shoot, or one from each look, and retouch them and send a low-resolution proof of the retouched images for them to compare to the raw images in the proofing gallery. This also underscores my opinion of what "the shots" are. More often than not, agents and talent end up using the images I pre-select. If nothing else, it gives them an image to post on their site right away, as it can be weeks before the agent and talent confer and reach consensus on "the shots."

SHOOT EDITS & SHOT SELECTION

I prefer to edit shoots on my own so I can pare down the images to best of the best, rather than quickly process the entire shoot and send it off to the talent and/or agency. I find this to be much more professional and your clients appreciate not having to wade through hundreds of photographs that are redundant or technically askew.

Don't overlook that the gallery or proof-sheet presentation is the photographer's show, essentially. You are selecting, cropping, rearranging and formatting images for show. I like to present my images in an online gallery that reflects some progression within each look and gives a bit of feeling of movement and flow. It's more impressive, and this step is really the primary phase where the photographer's work shines—at least upon first review.

I know fantastic photographers who shoot 800 images in a session and post every one of them to the proof gallery; they may take out the obvious "shut-eye" or "flash not fired" images, but then don't bother to create a portfolio out of the shoot. I'll shoot 400 to 800 images in a session and narrow it down to maybe 50 or 100, more or less. Every shoot is its own portfolio; present it that way!

Take the "less is more" philosophy; present the best images, eliminate redundant images, and try to showcase the subtle differences in expression and movement. I'm often told

> I'M OFTEN TOLD MY IN-CAMERA REVIEWS OR GALLERIES LOOK LIKE SLOW-MOTION MOVIES.

my in-camera reviews or galleries look like slow-motion movies. If you're the director and cinematographer on the shoot, now you're the editor (and maybe the sound designer, though I never add music to my galleries—I want the images to speak for themselves).

When I review a headshot or portfolio shoot at this beginning stage, I take a few different passes looking for different things in each pass:

> ▶ **PASS ONE**
> The first pass is purely technical—to delete shots that are unfocused, too over or underexposed to correct, closed eyes, zombie eyes, obvious problems.
>
> ▶ **PASS TWO**
> I reserve this pass to focus on body and expression. Anything that looks like a portrait, comes across posed, displays awkward body positioning, or shows smiles too big or not honest and sincere, is out.
>
> ▶ **PASS THREE**
> Having filtered out a chunk of the shoot, I reserve my final pass to eliminate redundant images and really narrow it down to the best of the best. This is where you'd use the comparison mode in your image review software to really judge the best of a cluster of shots that at first glance look similar. This is also where you determine the subtle differences in expression and facial nuance that are worth keeping.

Finally, I might also rearrange the order of photos to make the flow easier or more dynamic (i.e., put landscape-mode images together). This is a crucial stage for the photographer—you are still selling your images at this point.

All that done, it's still usually the handful of shots that really "popped" upon my first review that emerge as the winners. But before I rename the files and process for color and contrast correction, I walk away, give it a day (or at least a few hours) and come back with a fresh head. Photographers can get as excited about images as the talent, and need to let that initial energy fade to revisit the images with a bit more neutrality.

PROOF FORMATS AND DELIVERY

In the old days (way back in the 20th century), a photographer would throw his unprocessed film at his favorite lab and receive contact sheets, or proof sheets, which are the 8x10 prints of strips of film negatives. The only way to see these would be on a light table, using a loupe (a cute little magnifying glass thingy). It was kind of cool standing around the table, marking favorites with grease pencils and asking for enlargements.

Most photographers must now do their post-processing and proof delivery themselves. I still get requests for contact sheets, even though I shoot all digital; I'm happy to format

them and print them, even though viewing thumbnail images over a light table on normal photo paper is an incredibly silly thing to be doing when you can see them on your computer monitor, color-corrected and actual size.

To keep shoot expenses down (and what a photographer must ultimately charge the talent for), I provide a proof gallery, which I process and format using either Adobe Bridge or Adobe Lightroom (there are many other good, image processing programs which can do this) and post to my own FTP site. I then provide the talent (and/or the agent) the link to that gallery, which includes the file name of all images beneath each image, so they can tell me or email me their selections. My galleries include a direct email link to me.

A useful tool to provide is a "lightbox" function, which enables anyone viewing the gallery on their own computer to select favorites and compare on a virtual "light table." They can scrutinize images right next to each other to help their own decision-making process.

The digital, online proof gallery is the easiest and least expensive method of delivering proof images to the talent and the agency at one time. However, some agents or talent might prefer receiving contact sheets, even if emailed, so they can print out on their own home printer. For this, I format the images into 8.5 x 11 contact sheets (the standard printer size for home printer setups) and usually include 20 images per sheet, 4 columns/5 rows. Viewing these files online is a bit cumbersome, though within most browsers, they can be enlarged and reduced as needed.

When sending your digital files or posting your gallery, it is important to note that the receiver might not be seeing true colors, as their monitors are probably not calibrated to the photographer's. All monitors see different color ranges depending on their settings. Images can be remarkably different in tone, contrast and color. The important thing is that the photographer knows the true colors she shot and can do any color corrections on selected images.

CONFLICTING OPINIONS

It certainly can happen that a photographer shoots some terrific images but the talent does not like the final results. This is one reason why the preshoot meeting is important; the talent and the agency see the kind of work the photographer does, and know what they're likely to get. Also important is that talent see a preview during or just after the shoot, while still at the studio or on the location, so they know what to expect and give an approval. Sometimes I'll do an in-camera review with the talent and they'll feel they could do something better—expression or body position—and I'll keep shooting even if I feel I've nailed tons of good options. It's important that they feel they have the right shots and like how they look and come across—they will be living with these images for months or even years (and they'll be talking about who shot them).

What may also happen, when working with talent agencies, is that the agency and talent may not agree on image selections. The photographer can feel stuck in the middle. An agent should know the types of images and expressions that will sell their talent; but that does not always jibe with how a talent wants to come across. If asked for my opinion in these matters, I will usually nudge the talent to defer to the agent. But if I've listened carefully during the shoot and especially during the in-camera preview, I've likely gotten the range of images that I know will please the agency and the talent both. They will have to work out final selections between themselves.

The most frequent "ego" conflict of this type is when the talent sees themselves as something the agent doesn't—maybe the talent wants to come across sexier, younger, or hipper than the agency can market them as. The agency wants a good lifestyle image, not sexy fashion.

As long as the photographer and talent have been honest with each other and communicated well at the preshoot meeting and during the shoot, and both feel good about the images produced, the photographer has done his job. If an agent and talent get into a disagreement and ultimately decide to go for different images, it would not be fair at that point to go back to the photographer and ask for a reshoot at his expense.

TALENT SELF-ASSESSMENT

As the talent, what happens if you review these images of yourself and you just aren't satisfied with how you appear; you have some bulges, you need to do some body toning, you look tired, you just don't feel they represent you well. There are elements well beyond the photographer's and stylist's control; it's not their job to criticize you (though some will be perfectly frank and candid with you at the consult or during the shoot). Your body type, your weight and any characteristic such as your general hair style, color and length, are all things that are usually discussed between you and your agent. A photographer and stylist try to take what you are and capture that in the most flattering and honest way possible, in both physical appearance and how you project your expression. But they must work with what they're given.

Sometimes, however, the talent will look over the proofs and feel singularly unimpressed. Here's where some level of psychology and honesty needs to kick in. As talent, what were your real expectations, and were they realistic (were you expecting to look like a cover model?). It's

> EGO THAT COMES WITH PERFORMANCE-DRIVEN AND TALENTED PEOPLE IS FAMOUSLY SELF-CRITICAL.

easy to confuse dissatisfaction with one's self and appearance (getting' older?) with a "bad picture." A good, usable promotional image, whether you're an actor or a model, old and

haggard or beautiful and lithe (or haggard and lithe, which is really interesting to shoot), must be honest—and you have to be honest and realistic. Ego that comes with performance-driven and talented people is famously self-critical. I've seen talent both elated to the point of tears and reduced to tears by the reality of what they look like, even with great makeup and styling. Keep it real.

RESHOOT POLICIES

Different photographers have different reshoot policies. I will certainly reshoot, at no charge, if something happens to the images that was my fault, or if we didn't get the images we really felt we were going for. However, cultivating good relationships with agencies and talent eliminates the need for most reshoots because you know what they want and need. Good preparation beforehand and an immediate, in-camera or laptop post-shoot review can nearly eliminate any need for reshoots at all. Talent get to take a quick look at what was shot, approve and even point out some favorites or shots they'd like to see eliminated altogether. Or, perhaps they feel they can nail a different expression than they delivered. This is their opportunity to give a thumbs up or make any changes they'd like to see.

RETOUCHING

This is not a chapter on how to Photoshop®; it's about whether or not to Photoshop. There are tons of books and workshops on retouching software such as Photoshop and retouching

THE IDEA ISN'T TO LOOK PERFECT; IT'S TO LOOK REAL.

techniques. The idea isn't to look perfect; it's to look real. Really good—but real. If you're not keeping it real, then you're fooling yourself and misleading those you want to hire you.

By the way, Photoshop is a trademarked product of Adobe Systems, Inc. It's not a verb. But, like those lucky brands Kleenex, Hoover, and Google, it has become the standard in its industry and so is used as its own action word. Goody for Adobe. There are several other very good photo retouching programs out there used by professional and amateur photographers and hobbyists; but since we're dealing in the professional world and Photoshop is the professional standard, I feel no remorse in allowing Photoshop to represent the greater world of retouching software.

As with the photography and the styling, I highly recommend that any retouching be done professionally. Many (but not all) photographers do their own retouching and either figure that into their session charges or charge separately for retouching and delivery of images. Some photographers might have an associate or partner do the retouching. I cannot underscore enough how this is as vital a part of the image-making process as shooting and styling. It would be somewhat shortsighted of talent to invest in professional photography and styling to get a great headshot, then hand images off to a friend or student to do the finishing touches and corrections. Or, worse, to do it themselves—no matter how good a retoucher you think you are, the evil twin inside you will take it too far.

Imagine your face, head, and shoulders enlarged to poster size on a computer screen and scrutinized in detail. Blemishes, wrinkles, and blotchiness are diminished. Stressed out red in the eyes is removed and yellow in the teeth is taken out (for God's sake, people, invest in teeth whitener!).

Retouching is part forensic science, part painting, part dentistry and dermatology, among other sciences. I've wondered if I shouldn't learn more about skin cancers and diseases so as to warn people of what I'm seeing on their skin. Hair grows in some surprising places on the human body. Your nostrils are never as clean as you'd like to think. Things peek out of teeth—how closely do you check your teeth when you leave the house or after you eat? Hourly flossing should somehow be mandatory for all on-camera talent.

Retouching will also remove or smooth out temporary marks (blemishes, abrasions, etc) but should leave permanent marks (scars, tattoos, moles, freckles). On-camera talent with visible tattoos (face, neck, arms) need to know they are likely to be automatically disqualified for a lot of on-camera jobs. That cute little butterfly or that ooh so mystical Chinese symbol aren't usually what most hiring client advertisers have in mind. Sometimes, makeup or a skin patch can do a decent job of covering up a tattoo.

EFFECTS AND BACKGROUNDS

It's not uncommon to change the color of a background, or convert an image to black-and-white or other tinting to get an effect, but this should never be done for talent headshots, and should be used sparingly for model portfolio images. There are some amazingly talented Photoshop artists at work out there, and some very creative photographers who do very cool things to images; but there is a threshold at which you move beyond what is supposed to be a promotional image of a person and into the land of digital artistry.

Personally, I find dropping in backgrounds a bit cheesy, even if done well. Coloring white/greenscreen backs to match a color sample from some color on the model or wardrobe can be a good thing, but again, I caution keeping things real. It's quite common in the world of catalog shoots and keeps things within the market. It's currently trendy to convert model images to black-and-white, but that trend could change overnight. As always, watch what's going on with images at the top talent and modeling agencies, and play along with some of it.

SKIN TONES

In the world of working on-camera, being a certain racial and ethnic stereotype gets you jobs. Being a certain "type" or skin tone can land you a job or keep you from getting one. Are you equator-dark African-American, light South Asian, Mayan brown, Irish fair, mixed race? People look for types and mixes when they cast, and so capturing and color-correcting the most accurate skin tones on talent is vital. This is why photographers often make good retouchers; they know the skin, color and tones they shot. If it isn't the photographer doing the retouching, then it's a good idea to take a candid shot (in natural light) before the photo session, so the retoucher has a point of origin.

SKIN PROBLEMS

I have a rule: blemishes, scratches, bruises and temporary skin marks/lesions can be zapped right out. Teen or adult acne, if bad, is a tough call. If a talent is in treatment for the condition, most agents would prefer that it be touched up a bit. Acne scarring is permanent, and this is a part of your "product," like it or not, and it should be reflected honestly. If it can be covered with makeup, it's probably OK to remove in retouching.

Anything permanent (moles, permanent skin discoloration patches, tattoos, second noses) has to stay.

Colors need to be true. Hair color needs to be true. Eye color needs to be true. Again, if the actor shows up with a headshot that doesn't ring true, they're probably not going to get considered for that job.

BRACES

This is always a big question for parents of on-camera kids; when their child goes into braces, should they shoot new images, or hold off? And increasingly, we see adults with braces as well. The first consideration is how long the braces will be in place. For most, it may be one or two years, in which case they can take a hiatus from "the industry," or they will need to have images that reflect the braces. There's no hiding it. There are some options, though, depending on the willingness of your orthodontist:

- ▶ Invisilign™ braces (we're seeing more and more on-camera talent opt for this more expensive but beneficial treatment)

- ▶ Temporary braces removal for shots/work (this is not altogether practical, as removal and re-installation of braces can be painful and possibly expensive and is generally at the discretion of one's orthodontist)

MISSING TEETH

If you (or your child) have a temporary missing tooth, you can actually get temporary replacements made called "flippers." These are individualy molded teeth and can cost between $300 - $500 per tooth. If you (or your kid) do a lot of on-camera work, however, the investment can be worth it. Your dentist can steer you in the right direction.

"LIFE RETOUCHING"

In the world of what typically needs to be retouched on people's images, there are things that can be controlled and tended to (teeth whitening, skin moisturizing) and things that can't (stress zits!). So engage in some "life retouching" as a standard practice. If you're pursuing on-camera work, get your teeth whitened (have your dentist do a pro bleach job, or use over-the-counter whitening strips). If you take good care of teeth, skin and grooming, then your stylist, photographer and retoucher are eternally grateful.

But alas, too many—even those who rely on their image for work—do not take care of themselves. This is frequently seen in actors whose primary work has been stage and theatre

performance; that audience-to-stage distance and the thickness of stage makeup can be quite forgiving. A high-resolution digital camera five feet from one's face is, well, less so.

Retouching combines a fair amount of digital artistry like brushstroke technique mixed with varying amounts of skills in dermatology, forensics, anatomy, hair restoration, reconstructive surgery, aesthetician skills, and, sometimes, bodybuilding and gynecology. It is usually a very good thing to take a before-shoot candid of face and body to have an original canvas to refer to. Bad retouching can unintentionally alter the shape of a cheek or nose. Overzealous retouching leaves the subject looking plastic (I have made this mistake a few times too often—have a test print made of your retouching work before sending an image file or ordering prints/headshots). Talent can minimize the amount of retouching that needs to be done by taking care of those elements in their appearance that they do have control over.

OVERHEARD AT THE RETOUCHER'S DESK

Here are some comments and curses I've actually overheard at real live retouchers' computer stations (mostly mine). May these serve as cautionary tales for talent who aren't quite on the image-conscious bandwagon:

- Yay, more Oompa-Loompa skin!
- There is a tiny Amazon jungle in his nose.
- Does he actually think he can grow a moustache?
- She must have a morbid fear of bikini waxing.
- I wonder if I should tell him to see a doctor about this.

THE TEN MOST ANNOYING THINGS TO RETOUCH

These things are mostly preventable through good lifestyle choices (and smart shampoo choices)

1. Tiny dry flecks of skin around corners of mouth and eyebrows (moisturize!)
2. Dandruff (watch shampoo commercials!)
3. Red eyes (use eyedrops!)
4. Smoker's teeth (lifelong smokers have a special color to their teeth that defies any known color chart)
5. Fabric folds caught on bras (have the right size bra)
6. Hair with streaky tones and too many colors; this may look great for the party, but it looks awful on camera (please just pick a single color)
7. That little bit of flab you should be retouching daily at the gym (get to the gym already!)
8. Nasal hair (get a good nasal trimmer—it's like a nostril vibrator!)
9. Bruised Knees (What are these doing in a headshot?)
10. Hair roots (see #6)

REVIEW THE RETOUCHING

It is perfectly acceptable for talent to scrutinize the retouching work, as long as you bear in mind that the goal with promotional images is to keep them honest and real. Because you have spent a lifetime seeing yourself in the mirror, your eye will usually go to the one thing that seems off—or to the one flaw that you are obsessed with.

Here's a list of the basic retouching elements that could be expected (if necessary):

- Eye baggage/facial lines/crow's feet diminished (the key here is diminished, not erased! The diminishing should be to compensate for imperfect light rather than the skin lines themselves)
- Blemishes removed (not moles or other distinguishing permanent marks)
- Blotchy skin patches/tones smoothed and blended (if skin is uniformly blotchy, pasty or ruddy, that's a certain "character" trait, and I'm reticent to alter it—rather, I would diminish distracting patches)
- Stray hairs removed (I do not remove all stray hairs, only those that are distracting)

Here's a list of more skilled retouching needs (to be done properly):

- Hair coloring changed
- Backgrounds changed/altered
- Wardrobe coloring altered

THE SUBCONSCIOUS FLAW

To me—and I realize this is purely subjective—a perfect picture is a portrait. A headshot is supposed to capture someone honestly, and there is always some flaw present. I like to leave any minor flaw in a picture—particularly in the hair. I like the odd stray hair, some fold in the fabric, anything that's not immediately recognizable or distracting. If only on the subconscious level, it portrays the talent is human, real.

COLOR CORRECTION

Don't confuse retouching with color and contrast-correction, which is usually the first thing a photographer will do when processing images. Images will be lightened, darkened, given greater or lesser contrast, and different colors can be fine tuned (reds lessened, blues increased, i.e.). For photographers, there are countless books and online sources that deal with how to perform color-correction exercises. As a photographer, I prefer doing my own color-correction (and no, I don't always go by the book) because I know what colors I originally shot and how far I can "push" colors in whichever direction.

Here's another reason why you want your images professionally processed; your photographer and the retouching artist know how to handle color management. In the digital world, managing consistent color tones is one of the most challenging aspects of processing, printing and delivering images. Knowing how color tones are actually going to turn out in print—and how true those tones are to the original colors and skin tones as photographed—takes lots of experience in shooting, color-correcting in post production, and seeing the actual image in print on a variety of media.

MONITOR CALIBRATION

The photographer shoots the image in a certain "color space" in-camera. Those images are processed onto a computer that has its own color space and are viewed on a monitor with its own separate color space. Hopefully, these elements are all calibrated to see the same relative color gamut. A photographer knows how to process images for the printers he or she may use in order to achieve the truest tones possible. When someone who doesn't know the process takes their CD of images down to the local discount store to have them printed on the cheapest paper they can find, they risk getting poor prints or reproductions. Not only will they look cheap, they may misrepresent your skin tones, and would certainly misrepresent the quality of the photographer's work.

DELIVERING HEADSHOTS

Once the retouched and finalized headshot selections are done and ready for delivery, I usually send them to the talent in the full print resolution format and/or a lower resolution, web-ready version, depending on what was initially ordered. I always inform the talent of their options in ordering additional images, buying out images, any usage restrictions and copyright/photo credit information I might expect them to use where applicable.

A full resolution, printable headshot image is typically cropped, depending on the camera used and size of the original image capture, at 8x10, and should be 300dpi resolution.

A web-ready image file is typically converted to 72 dpi resolution.

There are plenty of variances and preferences on these standards, but these are good guidelines. Some websites may have certain specifications and you must always check those submission specifications before uploading your images to any site.

Since my studio is a full service shop specializing in tools for on-camera talent, talent usually orders their 8x10 formatted headshot (with the border and name) reproductions from my studio. We also produce comp cards, business cards, and other promotional media. Of course, not all photographers can offer this, so talent needing to reproduce their headshots or produce comp cards and other printed materials will need to check with their agency or check online for companies that print and/or design these tools. Searching for "professional actor headshots prints" or "model comp card printing" will yield oodles of hits.

REPRODUCTIONS, COMP CARDS & MEDIA

The images are shot, selected and retouched; now it's time to put them out in the market! Hopefully you and your agency are aggressive about using your investment, and utilizing a variety of print and internet media to showcase them and get them in front of the right eyes.

Depending on how you are marketing yourself, you and/or your agent will need to decide what tools would best promote you.

Not all promotional images need to be reproduced as headshots (in the 8x10 format with the name on the border), but until live holograms can be sent from your iPhone, it's the standard. If you are primarily an actor, you need your 8x10 commercial and/or theatrical headshots to hand out. If you also do corporate/industrial work, you'll need a professional headshot for that. If you do print modeling and/or lifestyle work, you or your agent may opt to print a comp card (also called a "zed" card), which is a 5 ½ x 8 ½ two-sided card with a headshot on the front and 2 or 3 images on the back showing a variety of looks, depending on your type. Some agencies utilize a "one-sheet," which is an 8x10 printed page displaying 2 or 3 images and the actor's name, with the resume on the back. If you are primarily a print model, you will need a comp card and a print portfolio book which holds 10-20 of your best, most recent images (from portfolio shoots, or tearsheets from good jobs).

Most any type of headshot or promotional image, however, will likely be used online—either via your agency's website or other talent listing sites, and your own website if you have one. More and more castings, at least in the initial stages, are being done via agency and talent websites. It's important to have images for web use optimized to the right size and resolution. The photographer will usually be able to supply images optimized for web use, but knowing how to resize and change the resolution of the image within your image browser (Windows Photo Viewer, Microsoft Office Picture Manager, etc.

For actors, at least one and often two or three headshots should be reproduced. A headshot is the image on an 8x10 print with a border around it and your name at the bottom. Most general professional actors always have on hand a commercial headshot (usually a great smile) and a film/theatrical headshot (usually a more dramatic expression). Other options would be a corporate headshot (typically in a suit). Agencies send different headshots to different clients, and you need to showcase your versatility.

For models, a portfolio book is a must, so your image selections will need to be printed portfolio size (usually 8 x12 or 9 x 12). Models typically will get the hardbound black portfolio books

through their agency, with the agency's imprint on the front and/or inside. Comp cards are also a must (5.5" x 8.5" double-sided cards with your images and stats); some agencies will have comp card templates on the model's page on their websites, available for downloading from potential clients given access to the site. Most models will also need to get the cards printed for mailing and client distribution.

Many on-camera talent will also use their images on their own business cards, 4x6 promo cards, and multiple websites.

Don't get cheap on printing—a great headshot will still look like crap if printed on crap paper, or cheaply copied, even on those nice new photo printers. Professionally printed headshots are on pro-grade paper. I have known actors try to save some $$ by getting a single pro print of their headshot from me, then going to the local warehouse club or copy store and running off color copies. They're really not saving much, and if not printed on professional grade (we're talking Kodak or Fuji) the copies look bad, fade fast, and bleed.

You should always have your print media professionally printed. Many agencies have relationships with headshot and comp card printers, or the photographers often do. If you do not have the option of ordering from your agency or your photographer, there are many printers around the country that specialize in headshots and promo cards, and from which you can place orders online. Search keywords such as "professional headshot comp card printers" and review a few to compare pricing. Be sure you know what format they require (color files in RGB or CMYK). Many printers who specialize in talent media will do the headshot name/border design, and comp card design. All online printers usually offer the options of uploading the image or images online, and some may have templates online through which you can do your own design.

If you are doing your own design, you will need to be careful to keep things clean and simple. Fancy and distracting fonts, color borders and extra graphics may seem cute and show personality, but you're only adding layers of distraction to the images, which are what should be selling you.

HEADSHOT BORDERS

Headshot borders should be plain and simple; just a white or black border around the image with your name on the bottom. Any attempt to use fancy, cutesy fonts or colors other than black usually result in casting directors sneering at them until they catch fire.

Sometimes an agency will put their sticker with agency contact info on the bottom border of the headshot as well, or it can go at the top of the actor's resume on the back. If you are talent representing yourself, your contact info (phone number, fax number and email address would suffice) should be kept on the back with your resume.

CREATING A QUICK HOME-PRINTED HEADSHOT

OK, I've stressed the importance of having your headshot printed professionally, but there may be times when you are caught between a rock and another rock and need to whip one off the 'ol home printer. If your printer, computer and monitor are not color-calibrated, this could take a while and get highly technical; we've already thrown out finessing color management for this one-off, so for a quickie print, the most important steps in your Print Setup dialog should be these:

- ▶ Select the proper format; portrait or landscape mode
- ▶ Select the highest (best quality) resolution, 300dpi
- ▶ Use the best glossy photo paper you have
- ▶ Use Print Preview to ensure you have everything formatted correctly
- ▶ Check to make sure your printer ink cartridges are not low on ink
- ▶ Print a test run to make sure colors are acceptable

You have likely printed your 8x10 headshot on an 8.5" x 11" sheet of photo paper, so you will need to trim that printed sheet down to a proper 8x10. Leave an inch to 2 inches at the bottom so you can print your name (assuming you do not have a properly formatted headshot file, just the image itself).

Glue, label or staple your resume to the back and there you have it; a makeshift headshot.

CREATING A SIMPLE HEADSHOT TEMPLATE IN ADOBE LIGHTROOM®

For photographers who use Lightroom, the industry-standard image processing program created by Adobe, it's easy to create a printable (or web resolution) file of a formatted headshot. These directions assume a basic understanding of Lightroom.

For an 8x10 Portrait Mode Headshot:

1. Display your final, retouched image in the main viewer
2. Go to the Print Module
3. In Layout Style, select "Single Image/Contact Sheet"
4. In Image Settings, check "Rotate to Fit" and set the Stroke Border at 1 or 2 points
5. In Layout, set your margins like this: Left 0.11; Right, 0.12; Top .24, Bottom .77
6. In Page Grid, set Rows and Columns at 1
7. In Cell Size, Height should be 8.98; Width should be 7.27
8. Under Page Setup, make background color white
9. Check Identity Plate; click the tiny down arrow in the lower right of the plate and choose Custom, then Edit
10. Choose Style Text Identity Plate and enter the name of the talent in the text box
11. Choose a standard text such as Arial or Times, use Bold, choose a point size between 20-30 (you can adjust in the next step), and select black for the text color
12. Adjust your opacity to 100%; adjust the Scale slider to make sure the text is not too small or large
13. On the image, move the text to the bottom left or right beneath the image, leaving enough white space around the name
14. In the Print Job section, make sure your Print Resolution is 300dpi, and the Custom File Dimensions are 8 x 10in.
15. In Color Management, sRGB would be the most typical choice

Then, in the upper left of Lightroom, click "Print" and choose "New Template" from the drop-down menu. Name the new template "Headshot-Portrait 8x10", or whatever works for you.

When that appears in the User Template selections under the Template Browser, be sure to right-click and choose "Update with Current Settings."

Finally, back in the Print Module, you can choose to print the image to a printer, or save as a .jpeg file. I usually Save to File, then save another copy at 72dpi for web use and to send to the talent or their agent as a proof copy.

To create a Landscape (Horizontal) Mode headshot, follow the same directions, but in the Layout section of the Print Dialog column, use these settings: Margins: Left 0, Right 0, Top 0, Bottom .77 Cell Size: Height 6.82, Width 9.28

Save your template as described previously, but designate it as "landscape" format.

LANDSCAPE VS. PORTRAIT MODES

Headshots have typically always been shot in "portrait" (vertical) mode; however, I'm seeing (and shooting) more and more in "landscape" (horizontal) mode, which gives the image a "wide-screen" energy; some describe it as more "cinematic."

Agents and casting professionals often prefer that landscape images be printed on a vertical 8x10. This means the wide image is reduced to fit on the upper half of the page, leaving a half page of white space, which freaks out actors who believe their image must fill the entire page. Don't get uptight about this! It's not the size of your image, it's the motion of…oh, never mind. It just makes headshot filing all nice and uniform for people who traffic in hundreds of headshots per day.

Landscape image formatted in 10x8 landscape mode.

Landscape image formatted to an 8x10 page; plenty of white space for signing autographs!

THE CARE AND FEEDING OF YOUR HEADSHOTS

Believe it or not, despite all the money and effort that went into your headshot, it's not indestructable. Here's a few tips to keep them looking good.

- ▶ Don't ever leave your portfolio books or stack of headshots in the trunk or backseat of your car—they will melt or warp. Headshots are like cockroaches—they like cool, dry, dark places.

- ▶ Keep headshots stacked flat or sandwiched between thick cardboard slabs held together with rubber bands; this keeps them flat and crisp.

- ▶ Laminating your headshots could be considered overkill.

DIGITAL PORTFOLIOS

Besides having your headshots on your agency's website, you should always keep your current web resolution images stored on your laptop computer, and your cell phone too. You never know when that last minute audition pops up, or you need to transmit an image to someone you've just met.

Larger Image Buyout Options: What Do I Get/What Do I Give?

During a typical headshot session, hundreds of images are shot, edited (hopefully) and selected images are retouched. It should always be clear up front how many fully retouched/ print ready images are included with the session. So what about all those other images?

I WANT MY DVD!

Some photographers might put all the images on a disc or DVD and hand it to the talent; this would seem to be a thrifty and generous service, but I discourage it for a few reasons. The most important reason is that images for professionals need to be professionally retouched and printed, and I have seen time and again talent taking multiple images off a CD and posting online, or having printed on their own, with, quite frequently, disastrous results. Unless they know how to deal with color management and how to work with professional retouchers (instead of their nephew who took that computer class in college), then they're getting a bunch of images that they don't really know how to handle (yes, this sounds horribly condescending, but it's for your own good, really).

Professional photographers who need to preserve the quality of their work as shown, and who are always careful about protecting their copyright, shouldn't be giving away their images, all of which are worth something, to them and to the talent. Photographers who

give away an entire shoot are either complete amateurs or independently wealthy and incredibly generous. I highly recommend that a good headshot photographer follow their images from creation to printing and keep a keen eye on the image's eventual usage. It is not in their—or the talent's—best interest to have a ton of free, unretouched images to get run off down at the drugstore or discount mart. It does not represent either party well and is a huge potential copyright abuse risk.

Most photographers will retouch and process additional image selections for a fee, usually somewhere between $20 - $50 per image. Some will give clients the option of "buying out" their image selections or the entire shoot. This usually entails the photographer creating a CD or DVD of images from the shoot, at full resolution, with global color/contrast corrections (though not necessarily individually retouched). This can be a great option if the talent is comfortable dealing with printers, color management, and computer files. Ask the photographer the terms of the buyout and make sure you also receive a letter with usage permission from the photographer (he still holds the copyright to all images), as some printers might require that before printing. Handling printing on your own means you assume responsibility for dealing with any color and quality issues with your printer.

A photographer cannot "give" away the copyright, so any wording making talent believe they will "own" their images is misleading at best. A photographer can provide formal permission for printing and usage.

PRINT PROCRASTINATORS

This is where talent can get tripped up easily. You've spent the money on the shoot and the styling but held off ordering your actual reproductions or prints. Weeks go by, or longer. All of a sudden that big unexpected audition pops up tomorrow, and you're making frantic calls to the photographer to "please just send anything" from the shoot for you to use. Don't wait long after your image review to order your reproductions; the clock is ticking on the longevity of those shots, and the value of your investment in them.

ATTACHING THE RESUME

The headshot isn't complete until you've attached your resume to the back. It should go without saying that your resume needs to be as professional looking as your headshot. A great looking headshot with a resume that is poorly constructed, misspelled, overly cutesy with several fonts, or filled with useless info (unless you're a child, elementary school plays are going back a bit too far) isn't helping your cause.

You can use several methods to attach the resume to the back; I don't recommend running your professionally printed headshot through your home inkjet printer to print on the back; it

can ruin your front image and the text will likely bleed or saturate the back. Typically, you'd get your resume formatted and professionally written on a word processing program and format it to fit an 8x10 page, with plenty of space around the border. Print as many as you need and trim to a fraction of an inch within 8x10.

To attach, you can:

- Staple the resume (though not usually recommended)
- Glue-stick or spray mount (can get messy)
- Tape (not guaranteed to stick and looks tacky, really)

Best option: purchase a package of 8.5 x 11" self-stick labels from your office supply store (these are specifically made for inkjet or LaserJet printers, know your printer make/model and ask at the store for the right product). Print several resumes at a time, formatted for an 8x10 space with plenty of white space around the border, and trim them down with a good paper cutter (or you can have the print shop at the office supply store trim them for you). Stick 'em on and enjoy.

COMP CARDS

Comp cards are also known as Zed cards or Model cards. They are typically 5.5" x 8.5" cards used primarily by print and lifestyle models. The front of the card displays the model headshot and usually their name and agency logo. The back displays 1 – 4 portfolio images, their stats (see below) and the agency contact info.

Designs for comp cards can be sleek and contemporary, or whatever the style or image of the agency's design motif calls for. However, as with headshots, the best fonts are simpler with clean lines and contrasting colors, insuring the details are easy to read. Too many images on the front or back is overkill; choose the best 2-5 images and let them do the talking.

Your stats need to be current and readable:

Stats for Women	Stats for Men	Stats for Children
Height	Height	Birthdate
Hair Color	Hair Color	Height
Eye Color	Eye Color	Hair Color
Dress Size	Suit Size	Eye Color
Bust Size	Shirt Size	
Waist Size	Pant Inseam	
Hip Size	Size	
Shoe Size	Shoe Size	

Generic comp card front

Generic comp card back

BUSINESS CARDS AND OTHER PROMOTIONAL MEDIA

If you're in the business of promoting yourself, whether you have an agent or not, you should be maximizing these great images you have and putting them on everything you can. Actors and models need to network, and a business card or 4x6 promo card with your name on it is a good thing to have on hand to give to those you might run into who are good contacts. Again, you've already made the investment in the styling and photography, hopefully you have your headshots and/or comp cards—now USE THAT IMAGE on everything from your website, email signature and cell phone avatar to your own personalized business cards. PROMOTE YOURSELF! Your agent can't do it all!

DIGITAL VIDEO HEADSHOTS, BIOS, SLATES, & AUDITIONS

It's becoming increasingly popular for professional talent to record a 30 – 60 second video of themselves and post it on the same sites as their headshots and resume. More and more agencies are requiring this, as more casting offices are demanding to see video of "the real person."

The quality of these videos are as varied as those of headshots. As you would suspect after getting this far in the book, the best option is to have your video shot and edited professionally. However, in the same way that you don't want to be overstyled in your headshot, your video must look natural and not be too slick, overedited, or use any cheesy video effects. It should be well lit, and sound quality is key; too much echo or background noise will ruin it. A hand-held boom microphone or wireless lavalier microphone option is best for capturing optimal sound quality with video.

Some headshot photographers are starting to delve into this kind of basic digital video work, and typical prices currently range from $125 - $400 for a 30-60 second spot, finished and edited in the proper digital file formats (i.e., Quicktime, mpeg4).

THE VIDEO HEADSHOT/BIO/SLATE

Since this is video and you are selling your personality and energy, it better come across and leave an impression by the time your minute's up. Standing in front of the camera and reciting your resume or your favorite foods and hobbies will produce yawns and fingers on the fast-forward button. You need some interesting facts about yourself and you need to relate such anecdotes in an engaging way. It's a good idea to have a professional help you script your bio, and as with any monologue, rehearse it and time it until you have it down. Practice yourself on your own home video camera before going to the shoot. The same styling, wardrobe choices and makeup artistry you used for your headshots should apply to your video headshots. Remember, you are projecting your own personality and energy!

THE VIDEO AUDITION

Actual auditions for specific roles do not need to be shot professionally; if you are with an agency, they may have you come down to do a basic audition taping to send on to the casting office or producers. Or, you may be asked to tape the audition on your own home video and

submit digitally. Professional quality is usually not expected on quick audition videos—but it is still in your best interest to be properly styled and choose smart wardrobe for the role.

If you are doing your own quickie video audition or bio, shoot inside against a solid colored wall with no other visual distractions (take down the Elk head and family pictues.) Light should be abundant and even.

THE HEADSHOT MARKET FOR PHOTOGRAPHERS

As an established or emerging professional photographer, how do you market specifically to those who need headshots and promotional images?

You first need to be sure your work in this area is competitive quality. Check out the websites of local talent agencies. Ask agencies what photographers they recommend for headshots and portfolio images, and check out those photographer's websites. Can you compete? If so, then you're ready to do some marketing. If not, you still have some portfolio-building of your own to do.

If you're just building your book in headshots and fashion/lifestyle, and are already an established photographer (i.e. of weddings or creative portraits), then offer to do one or two test shoots for free. If an agency or studio likes the general quality of your work, they may be happy to send some talent to test for free, or for prints. Another route would be to approach your local high school theatre groups or college theatre groups and offer to do headshots.

Regardless of whether you're shooting working professionals or amateurs, before you start charging, you should be shooting at a high level; your best starting point is to study the headshots of the top headshot and fashion photographers. Some talent agency websites list or provide links to the photographers they recommend.

Groups to market to (for actor/model headshots):

- Talent & Modeling Agencies
- Theater Companies
- Community Theatre Groups
- Dance studios
- Casting Offices
- University & College Theatre Schools
- Pageant Organizations

The first and best places to get started with headshots are your local talent agencies. Most urban markets have at least one talent agency that deals with on-camera commercial talent.

Some combine commercial/broadcast talent (acting in commercials, films, televisions, industrial videos) with print/modeling (catalogs, print ads, runway, fashion) talent. Again, before you approach them, be sure your portfolio book is high quality; you may not get a second chance to pitch your talents to them, especially in smaller markets.

Send promo cards with samples of your headshot work and basic prices (along with your website address and phone number) to the above targets. If you've done your homework on the competition, you know what other photographers are charging. Do you undercut that price? That's a tough question—isn't that the best way to get your foot in the door, by offering discounts and pricing lower than your competition, or offering more in your packages? In competitive theory, yes; but if the quality of your work is as good as the competition, why should you come cheaper? Let your work's quality get you in the door, and your professionalism and customer service keep the doors open.

If you are trying to get your foot into the door shooting fashion and print models, be prepared for lots of attitude. Most legitimate agencies have relationships with professionals who are working at a fairly high level. It's a huge plus if you're able to have some fashion spreads published in local style magazines before approaching agencies; but even if they like your work, they may expect you to start doing tests for free. Make no mistake, this is a lot of work and effort at your expense, all for the remote chance that they might put you in their roster of recommended photographers. True fashion photography takes a distinct eye and approach; if you're not plugged into the fashion scene and don't have access to great professional stylists who work in fashion/print, it might be best to stick to headshots and lifestyle or other promotional images.

It's vital that you gauge your competition; if you're in a major market, you'll have a greater potential talent pool to shoot, but a lot more competition. If you're in a small market with little competition, agencies may rely on traveling photographers from the bigger markets, and you'll have to show them that the quality of your work is as good as those pros.

MARKETING YOUR HEADSHOT — FOR TALENT

OK, you have a professional headshot and are ready to take those high paying on-camera job offers now. If you have an agency, hopefully they're doing their job and submitting your headshot, both the print version and the online one, for any job you might be right for. Most commercial agencies will have their own websites with which to promote talent, but will also list their talent on national casting sites; talent usually pays some kind of maintenance fee for these types of listings. But agencies are dealing with a roster of a lot more people, some of which compete with you for jobs. How can you use your headshot separately to complement the efforts of your agency (or if you don't have an agency)?

Start with your own website. There are tons of good websites offering web hosting and website templates, you don't have to be a programmer. If you're represented by an agency, you are probably listed on their website; but it's a great idea to keep your own website as well to feature a wider variety of images or details about yourself.

Social Networking sites such as Facebook, Linked In and MySpace are the more prominent self-promotion outlets now, just be careful about protecting your image, and keep your professional image separate from your personal pages.

Look at the local on-camera industry; there are likely websites devoted to audition announcements, theatre companies and other stage or film related sites. Look to see if they have options for talent to post headshots.

If you belong to a union (SAG/AFTRA/Actor's Equity), your local or regional union office might have a posting option for you. Check with your union on how else you might use your headshot online.

There are tons of websites for actors and models, but be cautious. Actor and model networking sites may charge monthly fees, may hide ownership of your images in their fine print, or may be constantly trying to sell you workshops and other services. This is not really where the professionals hang out online.

Of course, no matter where you want to use your image, it's a wonderful courtesy to give the photographer due credit wherever possible.

COPYRIGHT & IMAGE PROTECTION

You've done the shoot, the images are selected, corrected and prepped, they're being printed on headshots and comp cards and getting displayed on websites and promo cards and playbills and billboards. Mission accomplished? Not yet. In the digital age, you need to maintain some ongoing diligence to protect your image—and the photographer's copyright.

You've gone through the investment in time and expense to create a body of images that are crucial to your self-promotion; to drop the ball at this stage, when the images are actually supposed to be out there doing their job, could be a huge misstep that could cost you potential income, legal troubles, or at the very least, embarrassment.

WHAT CAN HAPPEN TO YOUR IMAGE WHEN YOU RELEASE IT INTO THE DIGITAL WORLD?

What can happen to your image when you release it into the digital world? What can you legally do with your images and what should and shouldn't you do with them? Worse, you may have shot with a photographer who plans to use your image commercially without your knowledge or compensation (if you are one of those photographers, you are evil and should be dragged to court, blacklisted by agencies, and have your images sold as stock without your knowledge).

This is another reason to do photo sessions with professionals. I've seen many an amateur photographer unable to even answer the questions of what should and shouldn't be done with images post-shoot. Most on-camera talent don't know what their vulnerabilities and protections are, either. Professional photographers understandably want to protect their images from potential copyright theft and also from misuse by the subjects of those pictures, so they usually take great care and respect with your image, and exact some control over how images are used and distributed (another important reason why giving out CDs of an entire shoot is risky).

For photographers, I suggest that you join a professional photographer's association such as the ASMP (American Society of Media Photographers) or PPA (Professional Photographers of America). They have terrific resources regarding copyright and legal issues as well as many other benefits.

WHO OWNS THE IMAGES?

When you hire a photographer to do your headshots or portfolio work, that photographer, by default, owns the copyright to all images he shoots. They may be images of you, but he created them and he owns them. Technically, he could use those images for anything he wants (unless it is defamatory or illegal) in any alterable form he might further create—though there are certainly gray areas in what he could legally do with them. He could sell those images commercially to a stock photo agency. A professional photographer with a good work ethic would not do this without some form of permission and model release, and a fair percentage of the profit paid directly to you or your agency. I recommend that agents and photographers have written agreements regarding the headshot, portfolio and test images shot with their talent. The photographer still owns the images, but you are working with professionals whose stock in trade is the image you shoot; I advocate an agreement where in both parties agree they cannot sell or distribute an image without mutual permission/payment.

USAGE

Talent (and their agents) should be clear on what usage they are allowed with their pictures. A photographer might give the talent a certain number of retouched images (as prints, or digital for web use) for them to use liberally as headshots or on business cards, comp cards, or website promotions (such as their own website or an agency's website). If the picture is to be published in a newspaper or other media as part of an article or other promotion, the photographer needs to be notified and permissions granted (most publications would require a photographer release or written permission for this kind of publication). A photographer always appreciates proper credit where possible; ask the photographer how he would like the credit to be listed.

Some talent might expect that a photographer should give them a disc of all images from the shoot. Photographer policies vary regarding this practice. Some include a disc of selected, retouched images, some will just burn a disc and hand it over, and some photographers are notoriously stingy with the number of images they're willing to pass on to the talent. This much is certain: professional photographers who give away discs of images are either extraordinarily generous or place no value on what they shoot. If they are running a business, those images –the shooting, editing, retouching and usage thereof—are what pays the bills. Amateurs give away images all the time because they think it increases the value of what they're offering, or better competes with pros who aren't so liberal with throwing images around. An entire disc of free crappy images doesn't help the talent. OK, I've officially stepped off my soapbox about those CD giveaways.

METADATA AND IMAGE TRACKING

Most photographers embed metadata into each image file. Data includes their copyright and contact information, key words describing the image, and some metadata services inject tracking codes into each image. This metadata can be read from within most popular image viewing software programs.

When you work an on-camera job, the copyright is owned by either the photographer, the studio, or the company who has hired them for the project. The photographer and the client will choose what images from the shoot will be used and whether the client will license the rights to use certain images for a certain period of time, in certain media, or they may opt to buy out the images altogether. The talent is paid a day rate and usage rate or buyout, so it's important you know how those images will be used. If you are represented by an agency, it is their job to secure the rates and usage.

When you order headshot or portfolio prints and reproductions, you can request that the photographer give you a digital copy (web-resolution) for use on your own website and your agency's website.

Typical Promotional Image Usage on the Internet:

- Personal Website
- Agency Website
- Casting websites such as Breakdown Services/Actor's Access or Talent Network
- Actor, Audition, Talent or modeling websites
- Social Networking sites (such as Facebook, My Space, Linked In and others)
- Modeling/Beauty or talent search contests

Both talent and photographer need to know where the images might likely be used. The photographer, understandably, wants to be sure the copyright is protected from unlawful use or duplication. Many websites that let you post pictures online do not protect those images from being downloaded. Check out the site before you post pictures (i.e., on

> READ THE FINE PRINT; SOME WEBSITES CLAIM OWNERSHIP OF ANY DOWNLOADED CONTENT

Facebook, you can "right-click" your mouse and choose the "Save Picture As" option—anyone could download your image and use it illegally). Read the fine print; some websites claim ownership of any downloaded content, or they claim an ability to use any posted contents for their own purposes.

Photographers and talent alike would be wise to frequently monitor the agency's website, or any website posting the headshot image, to make sure their images are displayed with accurate colors and no additional retouching or enhancements.

Beauty Contests

You have your images—you've never looked better! You're beautiful, you're sexy, you're a goddess in pixels! You could finally win that beauty contest you've always dreamed about!

Magazines, websites and other media in the commercial and modeling worlds frequently hold picture contests. Some charge a submission fee and some are free to enter. Again, read the fine print on the rules and regulations: many of these "contests" are basically a way to amass huge numbers of images that can potentially be sold as stock or used for their own promotional purposes. The contests may claim that any submitted image becomes their property. It's a violation of copyright for talent to submit images to which they don't hold the copyright. You should be especially diligent in contests involving sexually expressive posing, implied nudity, even just body/swimsuit shots.

THE TALENT/PHOTOGRAPHER RELATIONSHIP

Depending on the market in which you live, there may be a huge talent pool that regularly works on camera, or it may be too small a market to support full-time on-camera talent. There may be only one or a plethora of great professional photographers to work with. An agent may recommend a photographer who is out of town, probably because they like that photographer's style and have built a relationship with them over years. But when talent and photographer hit it off, sparks fly—great pictures happen, and usually a lot of fun and a great working relationship ensue. I've developed great relationships from shooting with talent multiple times; I'm thrilled that they keep coming back as a client, but it's the mutual collaboration that produces the results they're happy with.

On-camera talent should bear in mind that the photographer they shoot headshots or portfolio work with today might also be a commercial photographer who could possibly hire them for a job down the road. This underscores the importance of acting professional at your headshot session (yes, even though you're paying the photographer)—it starts your reputation in the industry. The photographer gives feedback to the agent, the stylist, potential commercial clients, and the chain continues.

Likewise, photographers are certainly aware that the talent they shoot today might (you know, that 1 in a million chance) end up with some fame or notoriety later—hopefully using their headshot. The photographer's professionalism and talent will surely be remembered, so they should take care to be respectful of the talent regardless of where in their career arc they may be at the time of the shoot.

So, just in case you missed it, the message of this little section is that whether you're a full-time, part-time, high-level professional or emerging beginner on either side of the lens, professionalism will always make a good impression.

GLOSSARY

This glossary is intended to clarify the meaning of certain terms thrown around in the industry amongst talent, agencies, casting directors, photographers and others, mainly referring to promotional images and the processes it takes to create them and use them. Of course there are tons of other terms, but I am limiting this glossary to those regarding shoots, images and usage of photographs.

Brings
Items of clothing or accessories talent is asked to "bring" with them to a shoot

Candids (a.k.a. "Digitals")
When you sign on with an agency or if you are submitting images for agency consideration, you will have digital "candids" taken. I'm being persnickety in trying to get people to stop calling them "digitals," because unless the photographer is shooting film, every image is digital. "Candids" more accurately refers to the unstyled, off-the-street "as-is" image taken with a digital camera.

Comp Card (aka, Zed Card, Model Card)
A 2-sided promotional card used by models and agencies for promoting a variety of looks of the model, showcasing their range or specific marketability. Typically would contain a headshot on the front and 1-4 images on the back, with their name, stats (height, weight, eye and hair color and wardrobe sizes) and agency logo/contact information.

Digitals
More properly referred to as "candids," the term "digitals" is often used to describe the unstyled "as-is" snapshots taken of talent so agencies and their clients can see them unstyled with little or no makeup. See my rant under "candids."

Headshot
An 8x10 print of the actor with a border around the image and the actor's name at bottom; usually has the actor's resume affixed to the back via label, glue stick or staple.

Looks
A "look" refers to images shot within a particular wardrobe, hair/makeup, and location scenario. Usually when talent changes wardrobe and has hair styled differently, and/or changes from location to location, that's considered a "look." Models need a few different "looks" to fill a comp card. Actors might require a couple of different "looks" to get a variety of promotional headshots.

Optical Range
The age range on-camera talent can represent. For example, a 15-year-old girl might naturally look 18, but with hair pulled back, she could appear 13.

Portfolio
This can refer to the body of work or "showcase" images used by a print/lifestyle model or a photographer. Usually put together in a hardbound portfolio book and/or showcased on a website. A model portfolio book would typically contain 10-15 of the model's strongest images. A photographer's portfolio could have twice that.

Reproductions
Copies of 8x10 headshots, printed in bulk quantities.

Tearsheets
This is literally derived from tearing out a printed advertisement in which your work is featured. The tearsheet would be displayed in your portfolio and shows you've been hired! Yay!

Test shoot
A shoot set up for a potential model to determine how they "read" and perform on camera. Also can be a shoot to determine a photographer's potential talent. "Test" does not always mean "free."

TFP/TFCD
"Time for Print," or "Time for CD". A model or talent will shoot with a photographer for mutual portfolio benefit. No money is exchanged, the photographer is expected to provide prints or a CD of images.

Zed Cards
See "comp cards"

FOR MORE INFORMATION

Visit **www.artoftheheadshot.com** for more information!

AGENCIES AND EDUCATORS!

Contact Lance Tilford about headshot events at your agency, theatre, or for your university/college theatre or photography program.

TALENT & PHOTOGRAPHERS

Now that this book is out of the gate, I'd love to hear from talent, agencies and photographers. Send me success stories and horror stories of your headshots or the experience of getting there. I'd like to post these shared items on the website and in the future editions of this book.

CONTACT

Lance Tilford
Lance@LTphoto.us
Limelight Studio
1125 N. Second Street
St. Charles, MO 63301

COMING IN 2012 FROM LIMELIGHT MEDIA

Art of the Headshot: Images
On Cue: What On-Camera Talent Need to Know to be Pro

ABOUT THE AUTHOR

Lance Tilford is a professional photographer and owner of Limelight Studio in the St. Louis area. He specializes in working with professional and emerging talent and works with talent agencies from coast to coast. He studied film at Columbia College, Chicago, and he studied photography at University of California-Berkeley. After spending about 20 years in the world of books and publishing, he opened Limelight Studio with his wife, Tamara, a career actress, model and professional makeup artist.

Together, they have worked with over 1,500 talents in need of great images. Lance's motto: "Life is fun when your name rhymes with "pants."

Lance Tilford | Lance@LTphoto.us
www.lancetilfordphotography.com | www.limelightstudio.us | www.artoftheheadshot.com

CPSIA information can be obtained at www.ICGtesting.com
Printed in the USA
BVIW12n1520310316
442491BV00002B/2